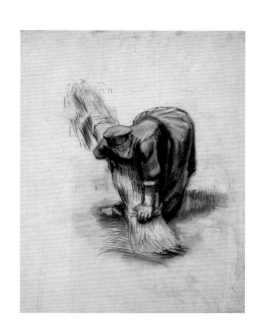

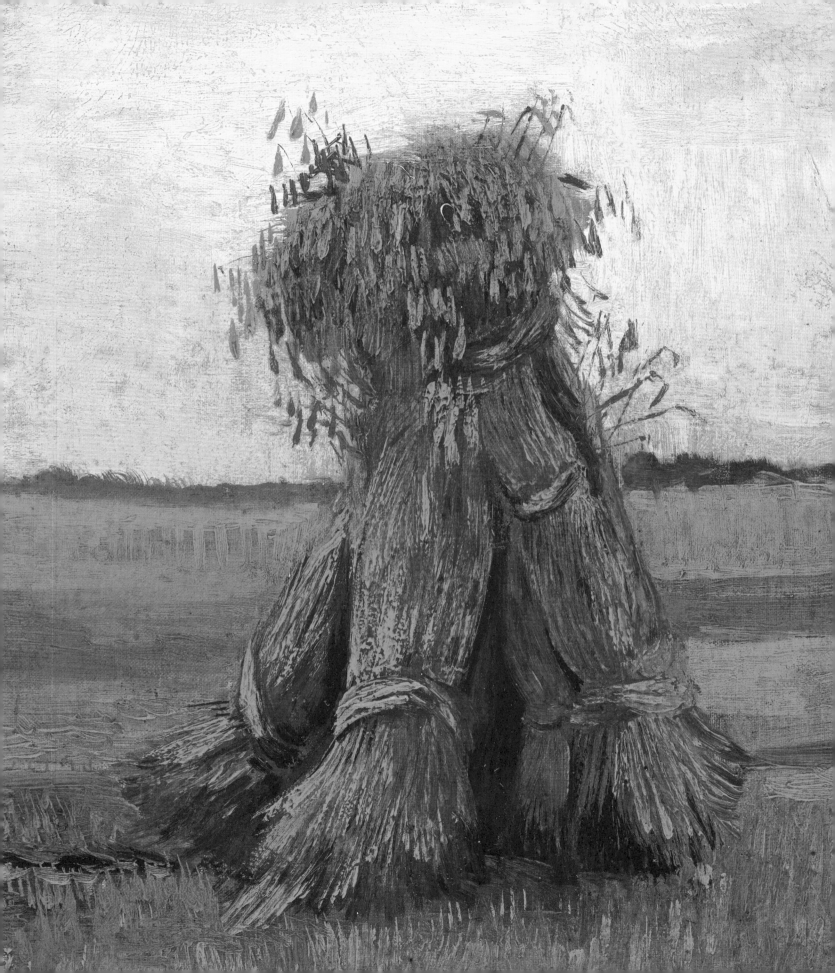

Van Gogh's
Sheaves of Wheat

Dorothy Kosinski

with contributions by

Bradley Fratello and **Laura Bruck**

Dallas Museum of Art

Yale University Press, New Haven and London

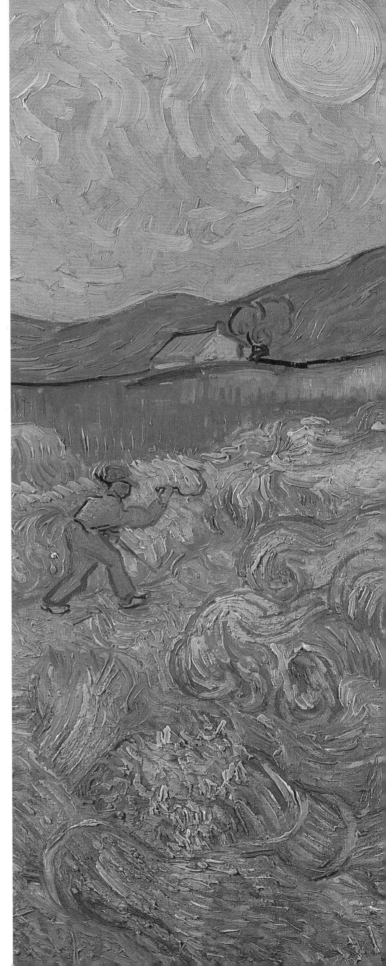

Van Gogh's Sheaves of Wheat
Dallas Museum of Art
22 October 2006–7 January 2007

The exhibition is presented by

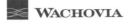

Additional support is provided by One Arts Plaza by Billingsley Company,
McKool Smith, P.C., and Essilor of America, Inc. Opening member events are
sponsored by Northwestern Mutual Financial Network, The Texas Group–Dallas.
Air transportation is provided by American Airlines.

Library of Congress Cataloging-in-Publication Data
Kosinski, Dorothy M.
Van Gogh's sheaves of wheat / Dorothy Kosinski ;
with contributions by Bradley Fratello and Laura Bruck.
p. cm.
Catalog of an exhibition held at the Dallas Museum of Art,
Oct. 22, 2006–Jan. 7, 2007.
Includes bibliographical references.
ISBN-13: 978-0-300-11772-1 (hardcover : alk. paper)
ISBN-10: 0-300-11772-8 (hardcover : alk. paper)
1. Gogh, Vincent van, 1853–1890—Themes, motives—Exhibitions.
2. Wheat in art—Exhibitions. I. Fratello, Bradley. II. Bruck, Laura.
III. Gogh, Vincent van, 1853–1890. IV. Dallas Museum of Art. V. Title.
ND653.G7A4 2006
759.9492—dc22 2006017592

Dallas Museum of Art
Dorothy Kosinski, Senior Curator of Painting and Sculpture
and The Barbara Thomas Lemmon Curator of European Art
Tamara Wootton-Bonner, Director of Exhibitions and Publications
Eric Zeidler, Publications Assistant
Laura Bruck, The McDermott Graduate Curatorial Intern

Edited by Lucy Flint
Proofread by Laura Iwasaki
Designed by Jeff Wincapaw
Typeset by Jennifer Sugden in PMN Caecilia
Color separations by iocolor, Seattle
Produced by Marquand Books, Inc., Seattle
www.marquand.com
Printed and bound in China by C&C Offset Printing Co., Ltd.

Distributed for the Dallas Museum of Art by
Yale University Press, New Haven and London
www.yalebooks.com

Contents

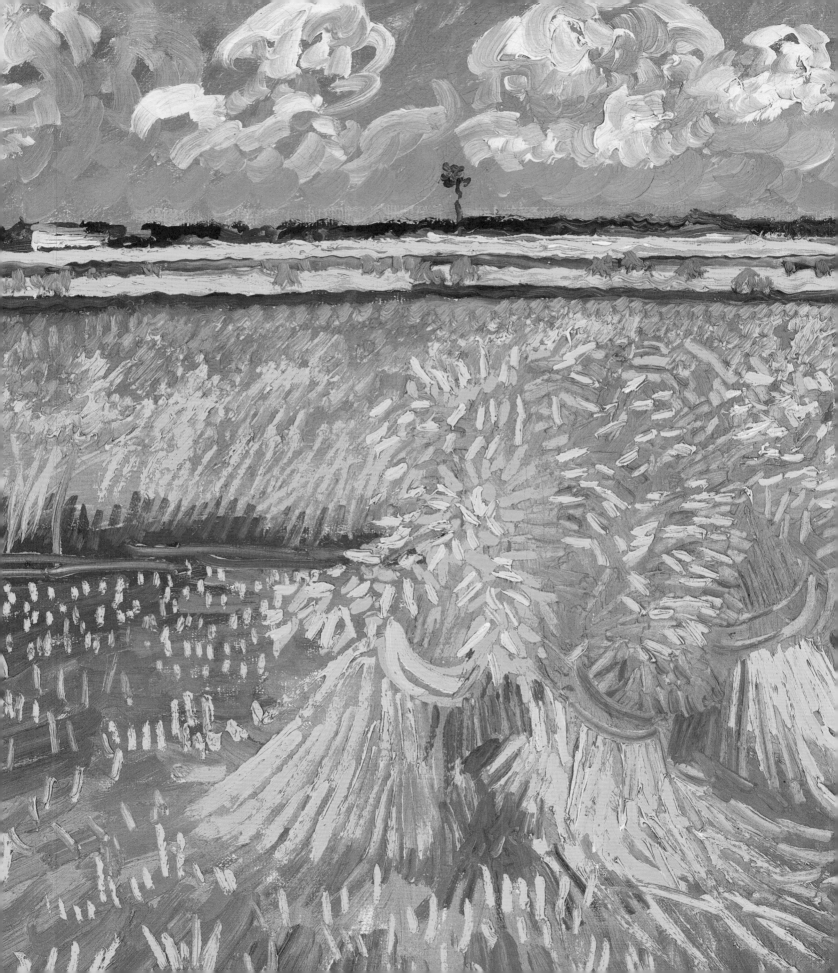

Lenders to the Exhibition

The Art Institute of Chicago

Ateneum Art Museum, Finnish National Gallery, Helsinki

Chrysler Museum of Art, Norfolk, Virginia

The Cleveland Museum of Art

The Corcoran Gallery of Art, Washington, D.C.

The Frick Art and Historical Center, Pittsburgh

Honolulu Academy of Arts

The Israel Museum, Jerusalem

The J. Paul Getty Museum, Los Angeles

Kröller-Müller Museum, Otterlo, Netherlands

Kunstmuseum Basel

The Marion Koogler McNay Art Museum, San Antonio

Musée Cantonal des Beaux-Arts de Lausanne

Musée des Beaux-Arts, Reims

Musée des Beaux-Arts, Rennes

Musée des Beaux-Arts, Rouen

Musée d'Orsay, Paris

Museum of Fine Arts, Boston

The Museum of Fine Arts, Houston

National Gallery of Art, Washington, D.C.

National Gallery of Canada, Ottawa

The National Museum of Art, Architecture, and Design, Oslo

Petit Palais–Musée d'art moderne, Geneva

The Snite Museum of Art, University of Notre Dame, Indiana

Sterling and Francine Clark Art Institute, Williamstown, Massachusetts

Tate

Terra Foundation for American Art, Chicago

Van Gogh Museum, Amsterdam

The Walters Art Museum, Baltimore

And the generous lenders who wish to remain anonymous

Director's Foreword and Acknowledgments

When the Wendy and Emery Reves Collection was inaugurated at the Dallas Museum of Art in November 1985, the enrichment afforded by its holdings in impressionist, postimpressionist, and early modern works and European decorative arts objects dramatically changed and advanced the fortunes of the DMA. Now, twenty years later, the Museum celebrates this collection in a variety of ways, including a campaign to refresh the signage and labeling in the galleries, a dedicated section on our website, and a number of special lectures and festive events. But the depth of the Museum's current appreciation of this extraordinary collection is perhaps best represented in this scholarly publication and exhibition project. Previous publications celebrating the riches of the Reves Collection include a catalogue prepared in 1985, with an insightful history of the Reves by Steven A. Nash, David T. Owsley, and Robert V. Rozelle, and the 1995 two-volume catalogue by Charles L. Venable and Richard R. Brettell that accompanied a special exhibition of the Reves treasures presented in the Museum's temporary exhibition J. E. R. Chilton Galleries. In contrast to these earlier collection overviews, this project focuses instead on a single great painting, Vincent van Gogh's riveting late work *Sheaves of Wheat*.

This project presents the opportunity to examine the work's importance in the context of Van Gogh's mythic career, exploring his remarkable preoccupation with this motif. However, expanding beyond a monographic focus, we include artists that Van Gogh greatly admired (Millet, for example) and his contemporaries, embracing impressionists, postimpressionists, and academic artists. This diversity highlights aesthetic differences, as each artist explores a personal view of the agricultural landscape, often inflected by regional qualities. For some artists, the sheaves of wheat have a biblical or mythic resonance. For others, the landscape or genre scenes reflect a nostalgic yearning for fast-disappearing social and economic traditions.

Our deep gratitude goes to WACHOVIA Bank, N.A., for the generous financial contribution that has underwritten the exhibition, and we offer special thanks to American Airlines; One Arts Plaza by Billingsley Company; McKool Smith, P.C.; Essilor of America, Inc.; and Northwestern Mutual Financial Network, The Texas Group–Dallas, for their support.

We thank Dr. Dorothy Kosinski, Senior Curator of Painting and Sculpture and The Barbara Thomas Lemmon Curator of European Art, for conceiving this project, framing its intellectual issues, and tenaciously pursuing the impressive group of international and national loans. Her thoughtful essays in this catalogue are accompanied by an enlightening contribution by Dr. Bradley Fratello, specialist on Millet and 19th-century French agrarian and genre painting, as well as informative biographies by Laura Bruck, McDermott Graduate Curatorial Intern at the DMA. The publication was produced through the efforts of Lucy Flint, editor; Laura Iwasaki, proofreader; Ed Marquand, Linda McDougall,

Jennifer Sugden, Marie Weiler, and Jeff Wincapaw at Marquand Books; and Patricia Fidler and Carmel Lyons at Yale University Press.

And at the DMA, staff members Jennifer Bueter, Kevin Button, Giselle Castro-Brightenberg, Diana Duncan, Brad Flowers, Evan Forfar, Lisa Jones, Michael Mazurek, Debra Phares, Bonnie Pitman, Chad Redmon, William Rudolph, Kevin Todora, Gabriela Truly, Tamara Wootton-Bonner, Charlie Wylie, Eric Zeidler, and Jeff Zilm all played important roles in bringing this catalogue and exhibition to fruition.

On behalf of Dr. Kosinski we also extend our thanks for the counsel, encouragement, and assistance of her colleagues and friends: Olga Amsterdamska, Claire Barry, Andreas Blühm, Richard R. Brettell, Susan Canning, Michael Clarke, Bill Cochrane, Stephane Connery, Patrick Derom, Marina Ducrey, Anne Dumas, Claire Durand-Ruel Snollaerts, Walter Feilchenfeldt, Anne-Birgitte Fonsmark, Margrit Hahnloser, Sjraar van Heugten, Waring Hopkins, John House, Hans Janssen, Paul Josefowitz, Hans Peter Keller, Ellen Lee, John Leighton, Gene Moore, Lynne Orr, Joachim Pissarro, Howard L. Rehs, Anne Sagnières, Dieter Schwarz, Soili Sinisalo, Susan Stein, Richard Thomson, and Frank Welkenhuysen.

Our particular appreciation also goes to the many colleagues who facilitated the crucial loans for this exhibition: James Cuno, Douglas Druick, and Gloria Groom at The Art Institute of Chicago; Maija Tanninen-Mattila at the Ateneum Art Museum, Finnish National Gallery, Helsinki; William J. Hennessey at the Chrysler Museum of Art, Norfolk, Virginia; Timothy Rub, Heather Lemonedes, and Charles Venable at The Cleveland Museum of Art; Paul Greenhalgh, Laura Coyle, and Jacqueline Serwer at The Corcoran Gallery of Art, Washington, D.C.; William Bodeen and Thomas Smart at The Frick Art and Historical Center, Pittsburgh; Stephen Little and Jennifer Saville at the Honolulu Academy of Arts; James Snyder at The Israel Museum, Jerusalem; Michael Brand and Lee Hendrix at The J. Paul Getty Museum, Los Angeles; E. J. van Straaten at the Kröller-Müller Museum, Otterlo, Netherlands; Bernhard Mendes Bürgi at the Kunstmuseum Basel; William Chiego at The Marion Koogler McNay Art Museum, San Antonio; Yves Aupetitallot and Catherine Lepdor at the Musée Cantonal des Beaux-Arts de Lausanne; David Liot at the Musée des Beaux-Arts, Reims; Francis Ribemont at the Musée des Beaux-Arts, Rennes; Laurent Salomé at the Musée des Beaux-Arts, Rouen; Serge Lemoine at the Musée d'Orsay, Paris; Malcolm Rogers and George T. M. Shackelford at the Museum of Fine Arts, Boston; Peter C. Marzio and Peter Bowran at The Museum of Fine Arts, Houston; Earl A. Powell, Philip Conisbee, Margaret Morgan Grasselli, and Alan Shestack at the National Gallery of Art, Washington, D.C.; Pierre Théberge at the National Gallery of Canada, Ottawa; Sune Nordgren at The National Museum of Art, Architecture, and Design, Oslo; Claude Ghez at the Petit Palais–Musée d'art moderne, Geneva; Charles R. Loving and Stephen B. Spiro at The Snite Museum of Art, University of Notre Dame, Indiana; G. J. Somberg, Michael Conforti, and Richard Rand at the Sterling and Francine Clark Art Institute, Williamstown, Massachusetts; Nicholas Serota, Jan Debbaut, and Sheena Wagstaff at Tate; Elizabeth Glassman and Elizabeth Kennedy at the Terra Foundation for American Art, Chicago; Axel Rüger and Louis van Tilborgh at the Van Gogh Museum, Amsterdam; Gary Vikan and Eik Khang at The Walters Art Museum, Baltimore; and the generous lenders who wish to remain anonymous.

John R. Lane
The Eugene McDermott Director
Dallas Museum of Art

Dorothy Kosinski

Van Gogh's
Sheaves of Wheat

I even work in the wheat fields, in the full midday sun, without any protection. . . .
I bask in it like the crickets.

Vincent van Gogh to Émile Bernard, June 1888

Van Gogh's *Sheaves of Wheat* of 1890, in the Wendy and Emery Reves Collection at the Dallas Museum of Art (cat. 31, pp. 40–41), belongs to an extraordinary group of paintings the artist executed during a brief sojourn in Auvers in the final weeks of his life. With one exception (*Mademoiselle Gachet at the Piano*, fig. 11), these thirteen double-square-format canvases, measuring 20 × 40 in., were all horizontal landscapes (fig. 1–10).[1] It is difficult to discern whether Van Gogh intended these works to be understood as a unified series. The subjects are disparate figures in a forest, a chateau at sunset, Charles-François Daubigny's garden, thatched cottages, an extraordinarily abstract tangle of tree roots and branches, and a landscape in the rain. At least five of the paintings, however, focus on grain fields, tracing the rapid ripening and ultimate harvest of wheat. These were all completed between the time fresh canvas was delivered to Van Gogh in mid-June and his death on 29 July.[2] With its dazzling contrasts of yellow and violet, the Reves picture celebrates the culmination of a cycle in nature. As will be discussed, this image is a powerful expression of Van Gogh's identification of the rhythms of nature and labor in the fields—from sowing to harvest—as analogies of the succession of birth and death. This painting, simultaneously agitated and radiant, executed just weeks before his death, communicates both the anguish and the joyous communion with nature that existed within the artist's psyche. Unencumbered by anecdote or narrative, *Sheaves of Wheat* reflects the contemporary symbolist preoccupation with the idea of the "soulscape" and depictions of "states of mind," notions that were championed by many contemporary theoreticians, artists, and critics who moved away from the tenets of naturalism and impressionism.[3]

Van Gogh's *Sheaves of Wheat* is infused with a sense of energy derived from the brilliantly contrasting colors, the powerful patterns of directional

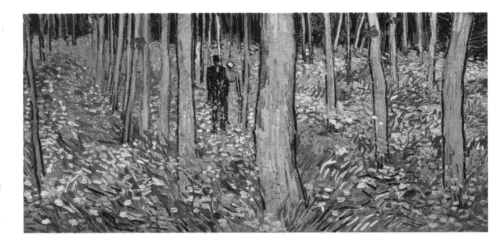

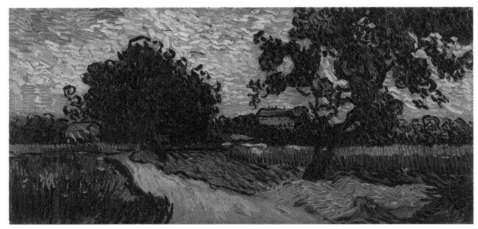

FIG. 1

Vincent van Gogh, *Undergrowth with Two Figures,* 1890. Oil on canvas. Cincinnati Art Museum, Bequest of Mary M. Emery

FIG. 2

Vincent van Gogh, *Landscape at Twilight,* June 1890. Oil on canvas. Van Gogh Museum, Amsterdam Vincent van Gogh Foundation

FIG. 3

Vincent van Gogh, *Daubigny's Garden,* July 1890. Oil on canvas. Collection Rudolph Staechelin, permanent loan to the Kunstmuseum Basel

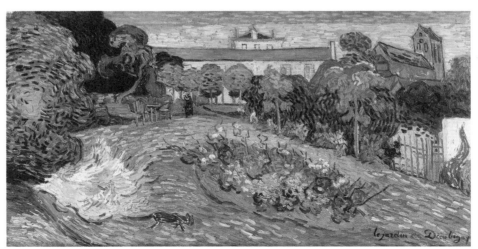

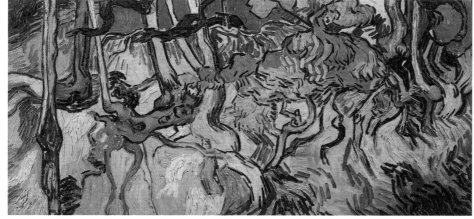

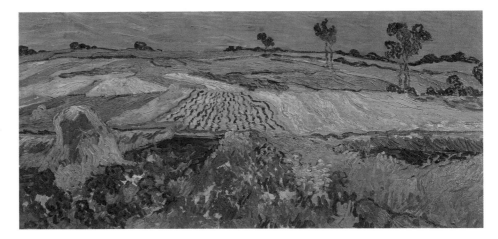

FIG. 7

Vincent van Gogh, *Wheatfield near Auvers,* June 1890. Oil on canvas. Österreichische Galerie Belvedere, Vienna

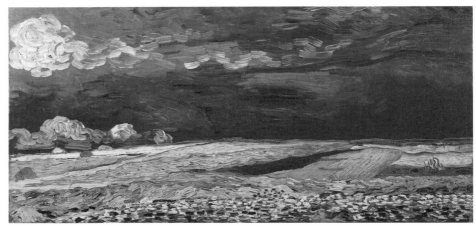

FIG. 8

Vincent van Gogh, *Wheatfield under Thunderclouds,* July 1890. Oil on canvas. Van Gogh Museum, Amsterdam Vincent van Gogh Foundation

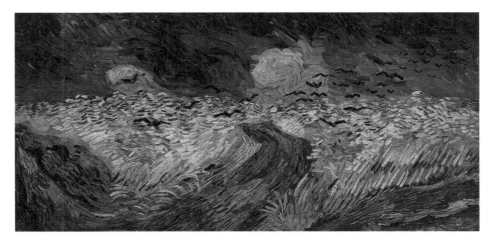

FIG. 9

Vincent van Gogh, *Crows in the Wheatfield,* July 1890. Oil on canvas. Van Gogh Museum, Amsterdam Vincent van Gogh Foundation

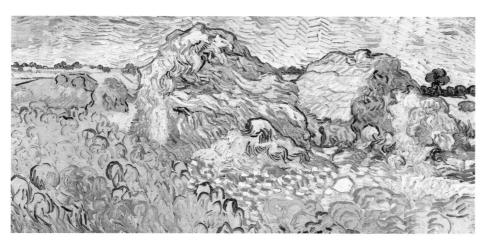

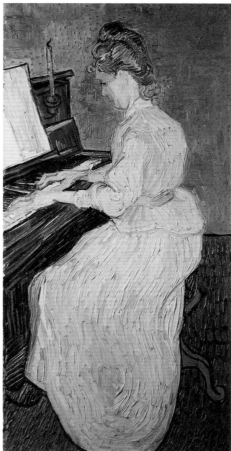

FIG. 12

Vincent van Gogh, *The Sower,*
1888. Oil on canvas. Collection
Kröller-Müller Museum, Otterlo,
Netherlands

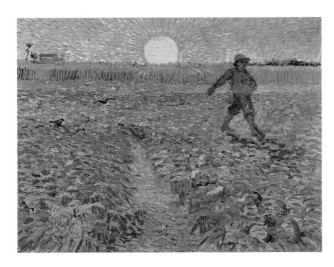

brush strokes, and the bold presence of the bundles of sheaves themselves. We stand amidst the shocks; they tower over us. The densely painted bundles have a physical presence that is almost anthropomorphic.[4] The stalks are like massive legs wrapped in golden trousers or skirts; the sheaves appear to stride powerfully forward, as though with enormous force. The shock at the left seems to lunge as though in exertion against an unseen counterforce. The thick bright yellow paint and the jabs of vivid vermillion make the central shock stand out, emphasizing the heavy ripeness of the wheat seeds waiting to be threshed. Perhaps most extraordinary is the undulating presence of the gray-blue shadow that curls along the ground to the right like the train of a gown or the bizarre tail of some monster. More than a landscape, this is a portrait of the massive sheaves of wheat. The horizon is cast so high as to eradicate spatial definition. The artist provides no reference to a specific place: it hardly matters that he painted this in Auvers. Instead, the focus is on the vibrant contrast between the hot yellows, golds, and ochers and the cool slate grays, gray-blues, violets, lilacs, and robin's-egg blues. The extended brush

strokes and the shorter hatches of paint—thick and sculpturesque—are orchestrated into broad swaths, undulating bands, and force fields of color that charge the painting with kinetic energy. Van Gogh's depiction defies the specifics of time and place while achieving an almost excruciatingly heightened appeal to the senses. He succeeds in bringing us outdoors, where we feel the intensity of his "hard close work among the fields in the full sun."[5] We share his euphoria and urgency as he works like the peasants he so admired: "quickly, quickly, quickly, and in a hurry just like the harvester . . . silent under the blazing sun."[6] In comparison with the traditional imagery of working peasants and the harvest, this symbolist painting engages us fundamentally, elementally: we are with Van Gogh and experience the heat and smell of the fields "like a cricket."[7]

In describing the abundant yellow flowers at Van Gogh's funeral, Émile Bernard remarked that yellow was "his favorite color, symbol of the light he dreamed of, in the hearts and in the works."[8] The luminous colors of Provence captured the artist's imagination, supplanting his earlier affinity for what he came to characterize as the "grayness" and "drabness" of Jean-François Millet, Anton Mauve, and Joseph Israëls.[9] Instead, he turned his imagination to Paul Cézanne, whose "color scheme [was] pitched very high. . . . So perhaps, perhaps I am on the right track, and am getting an eye for this kind of country."[10] Many of his letters from Arles and Saint-Rémy reflect his fixation with yellow. In a letter to Bernard, he described his composition of *The Sower* of 1888: "A field of ripe wheat, yellow ochre in tone with a little crimson" (fig. 12).[11] In another letter he wrote of a painting of a field of young wheat: "The field is violet and yellow-green. The white sun is encircled with a great yellow halo."[12] Writing of *Wheat Field with a Reaper,* he referred to "a yellow wheat field and a yellow sun," commenting that "it's not successful, but still in

FIG. 13

Eugène Delacroix, *Christ Asleep during the Tempest,*
c. 1853. Oil on canvas. The Metropolitan Museum
of Art, H. O. Havemeyer Collection, Bequest of
Mrs. H. O. Havemeyer, 1929 (29.100.131)

FIG. 14

Artist unknown (after J. J. van der Maaten),
Funeral Procession through a Wheat Field, 1862.
Engraving. Universiteitsbibliotheek, Amsterdam

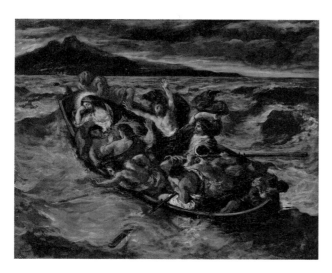

it I have tackled the devilish problem of yellow again"
(cat. 28, p. 36).[13]

His experience in Provence clearly reinforced his
interest in color theory, complementary color schemes,
and color symbolism.[14] For instance, he expressed his
admiration for Eugène Delacroix's *Christ Asleep dur-
ing the Tempest* of c. 1853: "I am speaking of the sketch
in blue and green with touches of violet, red, and a
little citron-yellow for the nimbus, the halo—speaks
a symbolic language through color alone" (fig. 13).[15]
He embraces color as independently powerful—"color
expresses something in itself"[16]—frequently exploiting
the vibration between yellow and violet in his land-
scapes. Eschewing traditional religious symbolism,
Van Gogh instead invested his spiritual yearnings in
the dialogue of mankind with the forces of nature as
manifested in the planting of the fields and harvest of
the crops. It is the peasant or the sun that is adorned
with a halo. For him, the sower and the sheaf are sym-
bols of "a longing for the infinite."[17] His "devilish prob-
lem" is not simply a painterly or technical one, but
rather it involves the unlocking of color for loftier, non-
descriptive purposes. The perfect yellow could embody

the infinite he desired to express; the yellow sheaves
are the tangible manifestation of the ineffable.[18]

The symbolic importance of the sowing and harvest
of the wheat fields was inscribed in Van Gogh's work
and imagination early on. While still in his twenties,
he wrote notes on the margins of his beloved copy of
a J. J. van der Maaten print (*Funeral Procession through a
Wheat Field,* 1862) that alluded to his profound and bibli-
cally infused identification of the cycle of nature with
that of life and death (fig. 14).[19] He explained this sym-
bolism in describing the image of the reaper painted
in Saint-Rémy in June 1889: "For I see in the reaper—a
vague figure fighting like a devil in the midst of the heat
to get to the end of his task—I see in him the image of
death, in the sense that humanity might be the wheat
he is reaping. So it is—if you like—the opposite of the
sower I tried to do before. . . . It is an image of pure
death as the great book of nature speaks of it—but
what I have sought is the 'almost smiling.' It is all yel-
low, except for the line of violet hills, a pale, fair yellow.
I find it queer that I saw it like this from between the
iron bars of a cell."[20] It is fascinating to trace Van Gogh's
expressions of his enduring faith in the rhythms of
nature and his earnest respect for the labors of the
fieldworkers in paintings and drawings throughout his
career, in the Brabant village of Nuenen in 1885, in Arles

in 1888, and in Saint-Rémy in 1889, as well as during the final months of his life in Auvers in 1890. Some of these works—his depictions of the sturdy peasant—clearly manifest his enthusiasm for literary naturalism, while others—the pure landscapes, especially the unusual close-up images of sheaves or ears of wheat—reveal the increasingly confident symbolism of his synthesis of nature and pure form.

The commanding black chalk drawings from Nuenen could not be more different from the Reves painting (cat. 14, p. 22; cat. 15, p. 23; cat. 16, p. 24; cat. 17, p. 25; cat. 19, p. 27). They convey a tremendous physicality; the women's bodies are massive and bulbous, like huge sacks of heavy material, their anatomy obscured by formless swaths of blouses and skirts. Their movements are essays in struggle against weight and gravity. They bend at the waist, their huge buttocks rearing upward as they wrestle awkwardly with the heavy sheaves of wheat they lift, bind, and haul. It is largely women—and only those not already occupied in the fields—who served as Van Gogh's models for these unsettling images of bovine, silent, sweaty, and lumpish humans at their toil.[21] Van Gogh's work in Nuenen—as his letters attest—prompted controversy. It was not easy to entice the peasant women to pose, a difficulty fueled by gossip about a girl's pregnancy and the local cleric's admonishment that the activity was improper and that Van Gogh should not, in any case, mix with people beneath him in class.

Considering Van Gogh's enormous enthusiasm for the naturalist fiction of Émile Zola, one almost immediately draws analogies between Van Gogh's Nuenen drawings and the images of the wheat harvest in Zola's *La Terre (The Earth)*, 1887.[22] The novel relates the story of a peasant revolt and violence against the backdrop of agrarian reform and hopeless poverty. Certain descriptions of endless stretches of wheat are astonishingly similar to Van Gogh's imagery: "Now it had become

a radiant golden ocean which seemed to reflect the glowing air, an ocean surging flame-like at the slightest puff of air. Nothing but wheat. . . . At times beneath the heat a leaden calm would descend on the ears of corn and a heavy scent of fruitfulness rose from the earth."[23] Zola elaborately described the labor of cutting the wheat with scythes, of carting and trussing, binding and stacking. He described in detail the peasant Buteau immersed in the rhythmic, backbreaking work with his scythe, followed by Françoise cutting with her sickle, prompting analogies with the awkward poses of Van Gogh's women. "When he straightened up just long enough to wipe his brow with the back of his hand and could see that she had fallen too far behind, with her buttocks sticking up in the air and her head level with the ground, in the posture of a female offering herself, he would call out harshly."[24] Long passages of the novel are devoted to descriptions of the hot and sweaty labor of the harvest interrupted repeatedly by mindless violence and brutish sexuality.

Van Gogh seems to have been impervious to these issues of propriety and class, focusing instead on the role of the human figure in art and the evolution of his aesthetic mission.[25] He was tormented by the difficulty of capturing laborers in motion: "Painting peasants or ragpickers and other workers . . . there are no subjects in painting as difficult as those everyday figures!"[26] "I have been keeping watch on these peasant figures and their actions here for one and a half years now, precisely to get some character into it."[27] For him, the peasant was the quintessentially modern subject: "To show the peasant figure in action, that—I repeat—is what a figure is—essentially modern—the heart of modern art itself. . . . Peasants' and workmen's figures began more as a 'genre'—but nowadays, with Millet, the perennial master, in the lead, that is the very heart of modern art, and so it will remain."[28] The drawings were a means toward technical proficiency, but more than

that, a step toward challenging admired masters of the genre: Millet, Jules Breton, and Léon L'Hermitte (cat. 42, p. 88; cat. 6, p. 69; cat. 37, p. 82).[29] Van Gogh's own hard work on these ambitiously scaled chalk drawings connects him directly with the arduous and life-sustaining labor of the harvesters: "And we go harvesting, and then both during the corn harvesting and the potato digging I must set to work. It is then doubly difficult to get a model and yet that is essential for I am becoming more and more convinced that one cannot be too conscientious, that one must always and eternally concentrate one's efforts on what Daudet [calls] *la chasse du modèle* (the search for the model)."[30] These impressive large-scale drawings not only reflect Van Gogh's sympathy with the naturalist's scientific approach to observation and description, but reveal as well his profound empathy for his subjects: "Painting peasant life is a serious business. . . . One must paint peasants as if one were one of them, as if one felt and thought as they do."[31] The drawings from Nuenen are proof of the spiritual and aesthetic seriousness of his undertaking.[32] Despite his complaints about dust and insects (and perhaps because of the difficulties of engaging models to pose in the studio), Van Gogh ventured out into the fields to produce more traditional landscapes—harvest scenes of peasants at work, with spires or windmills punctuating a distant horizon. He might also have been acceding to his brother Theo's request that the works include more context or atmosphere in order to be more saleable.[33] Shocks of wheat arranged in impressive rows came to dominate the compositions, receding along neat diagonals into the distance, infusing the works with dynamic movement (cat. 21, p. 29; cat. 22, p. 30; cat. 23, p. 31). The shocks themselves are vigorously modeled with dramatic black shadows, accentuating a sense of monumentality. The small oil in the collection of the Kröller-Müller Museum is unusual: a sturdy shock of sheaves centered in the composition is the solitary subject (cat. 18, p. 26). The painting's vertical format imbues the sheaves with nobility and strength, in contrast to the depictions of the laborers, whose lumpish forms express the oppression of their station. Van Gogh avoided the tension of working with models, and perhaps also the pressure of matching his own labor to the sweat of their brows. A compositional formula began to evolve that seems based on the figures' absence; this is a pure landscape that clearly relates to the Reves picture.

The shadow of Millet, however, was commanding and enduring, and even as Van Gogh moved away from naturalism, he continued to wrestle with his desire to paint monumental figurative compositions. Millet had an almost Oedipal influence: "In my opinion, there was still progress up to Millet and Jules Breton, but to surpass them—don't even think of it. In the past, present, or future their genius may be equaled, but it will never be eclipsed."[34] "Millet is the voice of the wheat."[35] "Father Millet."[36] Later, in 1889, during Van Gogh's confinement in the asylum at Saint-Rémy, he turned again to Millet for inspiration and consolation.[37] Copying Jacques-Adrien Lavieille's black-and-white prints after Millet's *The Labors of the Fields,* he wrote, both taught and gave him pleasure, in a process analogous to a musician's interpretation of a musical composition (cat. 34, p. 79; cat. 29, p. 37). It was about "searching for memories of their pictures . . . much more translating them into another tongue than copying them."[38] The prints are the points of departure for explorations of dynamic color schemes. Van Gogh returned to Millet to pay homage, to stand again on the "holy ground"[39] that he associated with the earlier artist, but also to nurture his own skills, to exercise the muscles of his artistic training and visual recall.

The pure landscapes and those in which objects in nature—sheaves of wheat, for example—supplant human form were simultaneously compelling to Van

Gogh, directing him away from naturalism rather than toward symbolism. The Honolulu picture, for example, features a huge shock of wheat sheaves that dominates a composition otherwise "constructed" with horizontal bands of animated brush strokes: a foreground of stubble, a middle ground of as yet unmowed wheat, a horizon indicated with long ribbons of color, and an uppermost section showing a stretch of cloud-studded blue sky (cat. 25, p. 33). The power of the painting derives from the tension between this highly structured geometry and the explosive vertical energy of the sheaves.

In the aforementioned *Wheat Field with a Reaper,* the figure of the worker is subsumed by the undulating fields of grain that surround him (cat. 28, p. 36). Van Gogh achieved an extraordinary balance between the tiny figure repetitively laying down bundles of wheat and the immensity of the fields, mountains, and sky. The equilibrium is both formal and symbolic, an expression of Van Gogh's profound convictions about human life, nature, and the redemptive role of the artist. It is a simple scene, glimpsed from his window at the asylum, resonating with his own physical and psychological misery and redolent with Christian meanings: "I then saw in that reaper . . . the image of death, in the sense that humanity was the wheat he was reaping."[40] Van Gogh's message is about his mortality and ours, in an image that is radiantly beautiful and profoundly consoling. He observed: "But there's nothing sad in this death, it goes its way in broad daylight with a sun flooding everything with a light of pure gold."[41]

Van Gogh seems increasingly to aspire to a personal fusion with the inexorable forces of nature. *Ears of Wheat,* June 1890, in the collection of the Van Gogh Museum, depicts neither the human figure nor a traditional landscape (cat. 30, p. 38). The fields and stocks are transformed into an allover pattern, a tapestry-like surface infused with undulating linear rhythms. The work is spatially ambiguous and anti-naturalistic,

offering scant clues about up or down, sky or foreground. The painting is emotionally ambiguous, too, perhaps expressing the conflicting emotions the artist spoke of in relation to his last double-square pictures, which "express sadness, extreme loneliness," while showing "how healthy and invigorating" the vast expanses of the landscape were.[42] Perhaps in his pure landscape Van Gogh found freedom from the weight of his mission as an avatar of Christ. In his symbolist compositions he claims his authentic voice.

Notes

1. The thirteenth canvas is a nearly identical version of *Daubigny's Garden.* The second version can be found at the Hiroshima Museum of Art in Japan.

2. See Richard Brettell, *Impressionist Paintings, Drawings, and Sculpture from the Wendy and Emery Reves Collection,* exh. cat. (Dallas: Dallas Museum of Art, 1985), 98–99, and Ronald Pickvance, *Van Gogh in Arles,* exh. cat. (New York: Metropolitan Museum of Art in association with Harry N. Abrams, 1984).

3. For a concise overview of these essential symbolist concepts in the hands of artists such as Stéphane Mallarmé, Gustave Kahn, Théodore de Wyzewa, Eduard Schuré, Alphonse Germain, and Hermann Bahr, see Dorothy Kosinski, "With George Rodenbach—Bruges as a State of Mind—The Symbolist Psychological Landscape," in Philip Mosley, ed., *Georges Rodenbach: Critical Essays* (Madison/Teaneck: Fairleigh Dickenson University Press, 1996), 129–60.

4. Concerning Van Gogh's tendency to anthropomorphize objects, see Chris Stolwijk, "Van Gogh's Nature," in *Van Gogh's Imaginary Museum: Exploring the Artist's Inner World,* ed. Sjraar van Heugten, Leo Jansen, and Chris Stolwijk, exh. cat. (Amsterdam and New York: Van Gogh Museum in association with Harry N. Abrams, 2003), 27.

5. *The Complete Letters of Vincent van Gogh,* 2nd ed., 3 vols. (Greenwich, Conn.: New York Graphic Society, 1959), 2: 591 (501). The numbers for Van Gogh's letters are provided in parentheses in this and subsequent references to this publication.

6. Douglas Lord, ed. and trans., *Vincent van Gogh Letters to Émile Bernard* (New York: Museum of Modern Art, 1938), 51 (9). The numbers for Van Gogh's letters are provided in parentheses in this and subsequent references to this publication.

7. Lord, 38 (7). See also Colta Ives, "Summer Harvest," in *Vincent van Gogh: The Drawings,* ed. Ives, Susan Alyson Stein, Sjraar van Heugten, and Maria Vellekoop, exh. cat. (New York: Metropolitan Museum of Art; Amsterdam: Van Gogh Museum; New Haven and London: Yale University Press, 2005), 189–221.

8. Jan Hulsker, *The New Complete Van Gogh: Paintings, Drawings, Sketches: Revised and Enlarged Edition of the Catalogue Raisonné of the Works of Vincent van Gogh* (Amsterdam and Philadelphia: John Benjamins, 1996), 480.

9. Lord, 38 (8).

10. *Complete Letters,* 2: 583 (497).

11. Lord, 38 (7).

12. Ibid., 99 (21).

13. Ibid., 100 (21).

14. In this regard, see Chris Stolwijk, "Van Gogh's Nature," in Heugten, Jansen, and Stolwijk, 34–35.

15. Debora Silverman, "At the Threshold of Symbolism: Van Gogh's *Sower* and Gauguin's Vision *After the Sermon,*" in *Lost Paradise: Symbolist Europe,* exh. cat. (Montreal: Montreal Museum of Fine Arts, 1995), 107. *Complete Letters,* 2: 597 (503).

16. *Complete Letters,* 2: 426 (429). For a discussion of Van Gogh's interest in color theory and his knowledge of Charles Blanc's study of Delacroix's use of color, see Judy Sund, "The Sower and the Sheaf: Biblical Metaphors in the Art of Vincent van Gogh," *The Art Bulletin* 70 (December 1988): 660–76.

17. Lord, 39 (7).

18. Ibid.

19. For a detailed discussion of this point, see Joan Greer, "'Christ, This Great Artist'—Van Gogh's Socio-Religious Canon of Art," in Heugten, Jansen, and Stolwijk, 61–72. See also Tsukasa Kōdera, *Vincent van Gogh: Christianity versus Nature* (Amsterdam and Philadelphia: John Benjamins, 1990), 13–18.

20. *Complete Letters,* 3: 202 (604).

21. For a discussion of class and sexuality in Van Gogh's Nuenen drawings, see Griselda Pollock's Marxist, feminist, psychoanalytic essay "The Ambivalence of the Maternal Body, Re/drawing Van Gogh," *Differencing the Canon: Feminist Desire and the Writing of Art's Histories* (London and New York: Routledge, 1999), 40–63.

22. In her essay, Pollock aptly points to the confluence of wheat harvest and over-heated sexuality in Zola's *La Terre (The Earth),* trans. Douglas Parmée (1887; London: Penguin Books, 1980). See esp. 52–53. See also Judy Sund, *True to Temperament: Van Gogh and French Naturalist Literature* (Cambridge, England: Cambridge University Press, 1992), 126–32. Van Gogh discusses Zola's novel in his letters; see *Complete Letters,* 1: 394 (212), and 3: 7 (520).

23. Zola, 237.

24. Ibid., 241.

25. It is precisely this purported ignorance and the perpetuation of this attitude by subsequent critics and art historians that provoked Pollock's furious essay.

26. *Complete Letters,* 2: 400 (418).

27. Ibid., 396 (416). Quoted in Johannes van der Wolk, Ronald Pickvance, and E. B. F. Pey, *Vincent van Gogh: Drawings,* exh. cat. (New York: Rizzoli, 1990), 131.

28. *Complete Letters,* 2: 401 (418).

29. Van der Wolk, Pickvance, and Pey, 131.

30. *Complete Letters,* 2: 392 (414). Quoted in Van der Wolk, Pickvance, and Pey, 131.

31. *Complete Letters,* 2: 371 (404). See also Nienke Bakker, "On Rustics and Labourers: Van Gogh and 'The People,'" in Heugten, Jansen, and Stolwijk, 87–98.

32. Sund, *True to Temperament,* 126–32.

33. Hulsker, *New Complete Van Gogh,* 192.

34. *Complete Letters,* 1: 477 (241).

35. Ibid., 3: 232 (614a).

36. Ibid., 2: 363 (400).

37. Ibid., 3: 216 (607).

38. Ibid., 216 (607), 227 (613).

39. Ibid., 1: 28 (29).

40. Ibid., 3: 202 (604).

41. Ibid.

42. Ibid., 3: 295 (649).

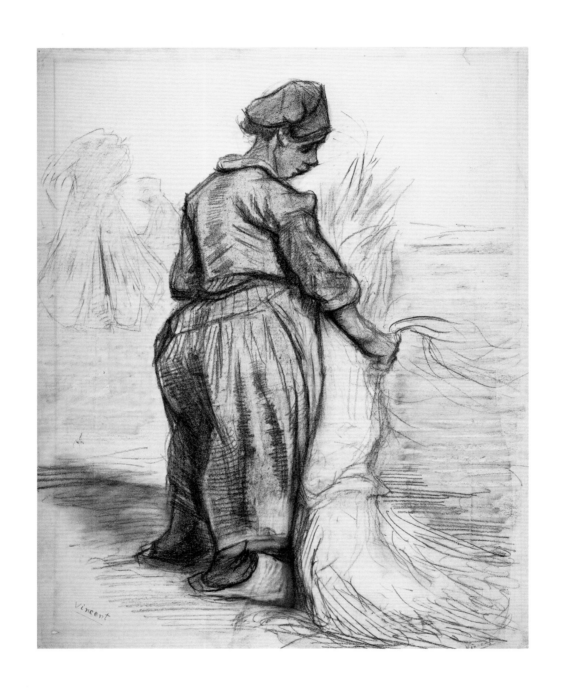

Vincent van Gogh

Peasant Woman Binding a Sheaf of Grain

August 1885
Chalk on paper
Collection Kröller-Müller Museum, Otterlo, Netherlands
Cat. 14

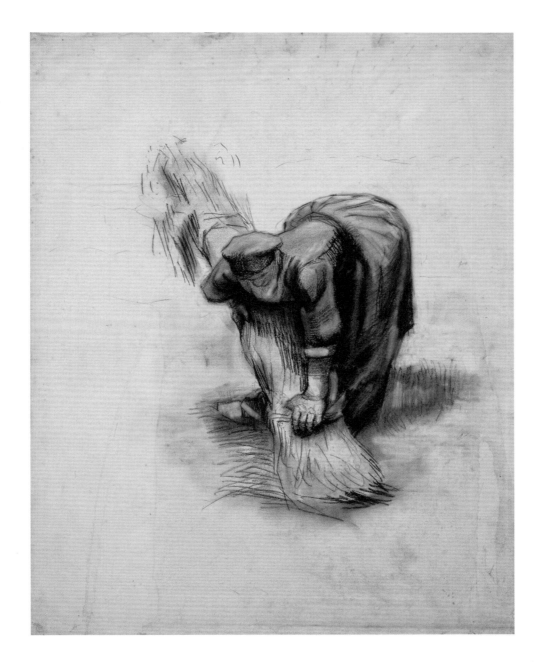

Vincent van Gogh

Peasant Woman Binding Sheaves

August 1885
Black chalk on paper
Van Gogh Museum, Amsterdam
Vincent van Gogh Foundation
Cat. 15

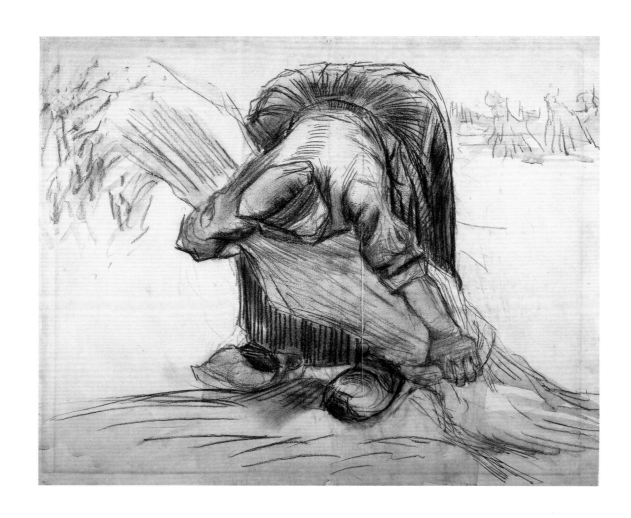

Vincent van Gogh

Peasant Woman Binding Wheat Sheaves

August 1885
Chalk, washed, on paper
Collection Kröller-Müller Museum, Otterlo, Netherlands
Cat. 16

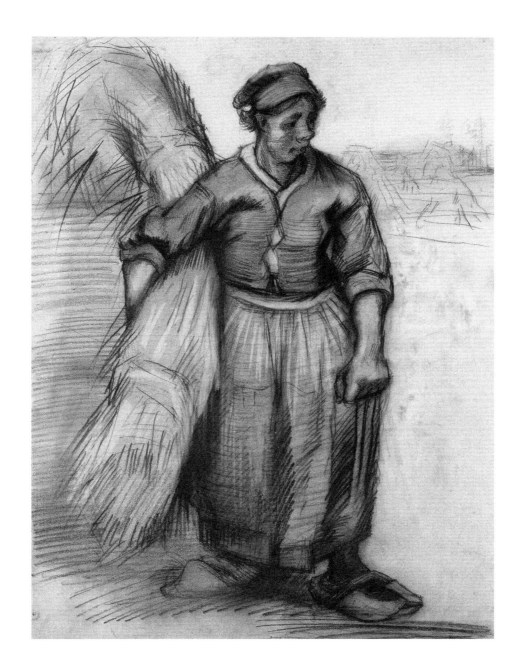

Vincent van Gogh

Peasant Woman, Carrying a Sheaf of Grain
August 1885
Black chalk on paper
The National Museum of Art, Architecture,
and Design–National Gallery, Oslo
Cat. 17

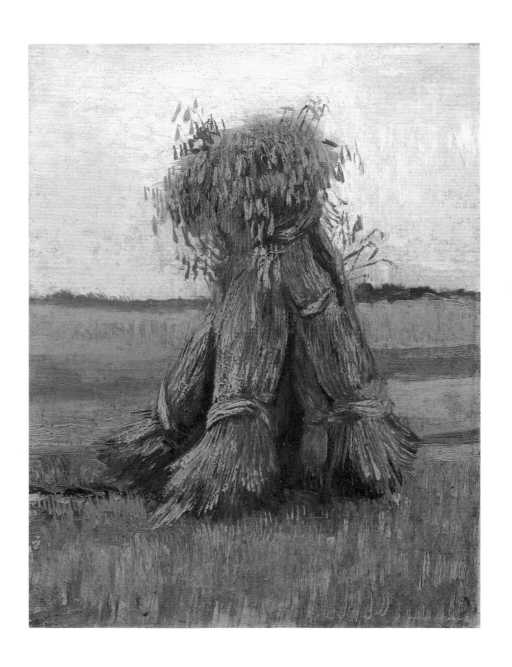

Vincent van Gogh

Sheaves of Wheat

Second half of August 1885
Oil on canvas
Collection Kröller-Müller Museum, Otterlo, Netherlands
Cat. 18

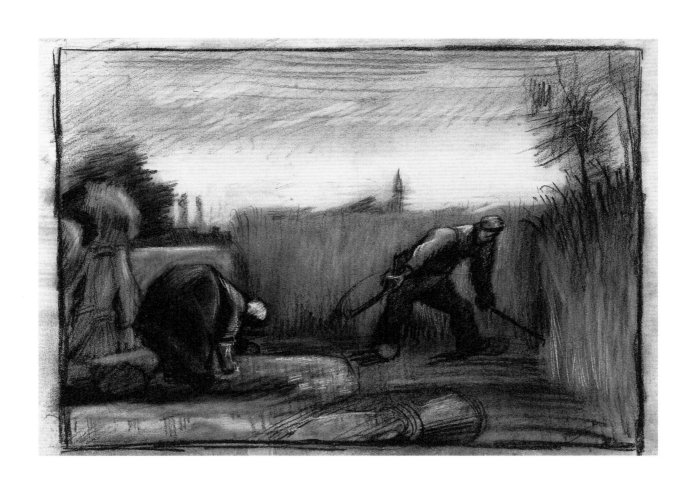

Vincent van Gogh

Wheat Field with a Reaper and a Peasant Woman Gleaning

Second half of August 1885
Chalk and paint on paper
Collection Kröller-Müller Museum, Otterlo, Netherlands
Cat. 19

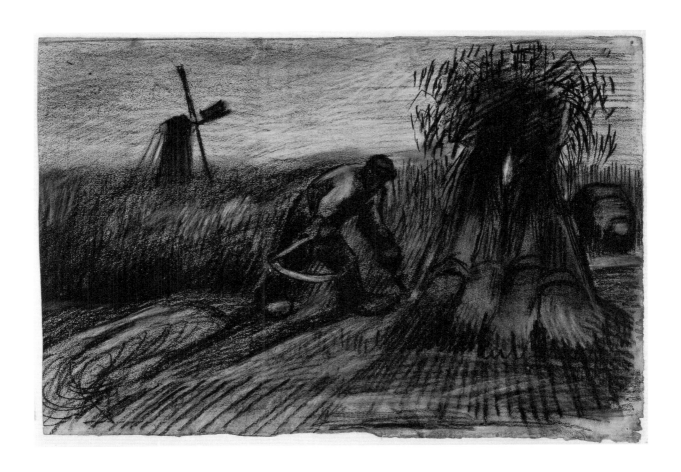

Vincent van Gogh

Wheat Field with Reaper and a Woman Binding Sheaves

Second half of August 1885
Black chalk on paper
Van Gogh Museum, Amsterdam
Vincent van Gogh Foundation
Cat. 20

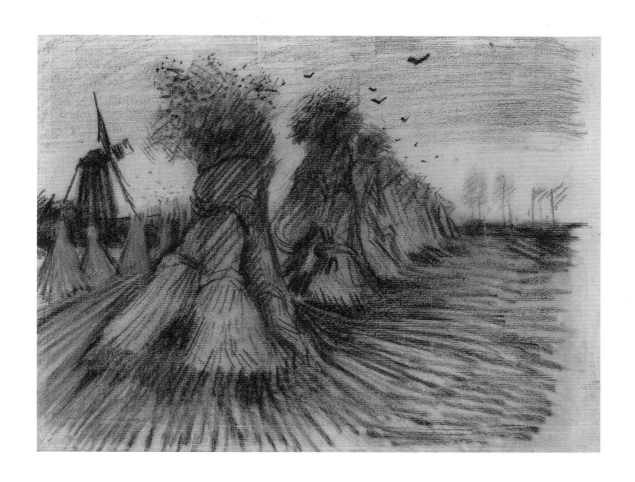

Vincent van Gogh

Stooks and a Mill

Second half of August 1885
Black chalk, heightened with white, on paper
Van Gogh Museum, Amsterdam
Vincent van Gogh Foundation
Cat. 21

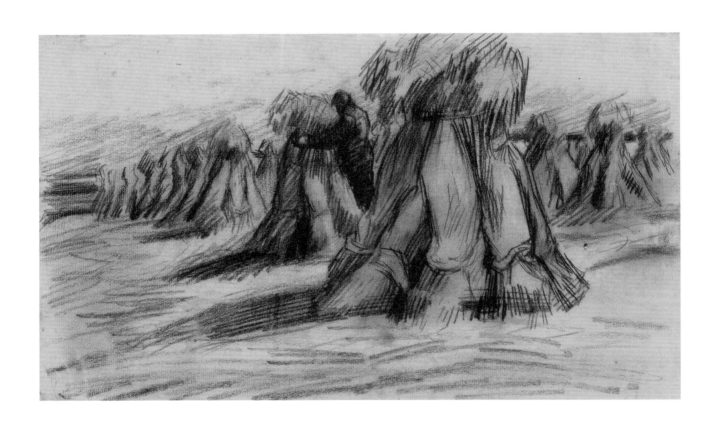

Vincent van Gogh

Stooks and a Peasant Stacking Sheaves

Second half of August 1885
Black chalk on paper
Van Gogh Museum, Amsterdam
Vincent van Gogh Foundation
Cat. 22

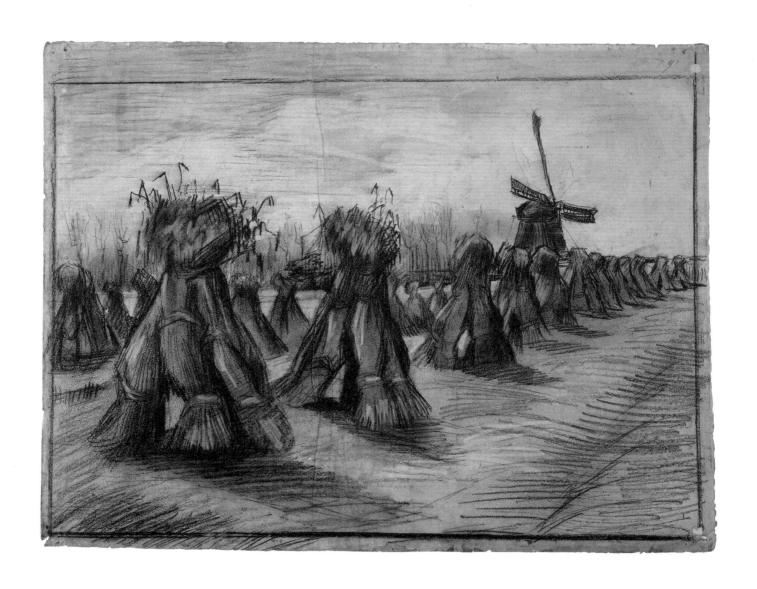

Vincent van Gogh

Wheat Field with Sheaves and Windmill

Second half of August 1885
Black chalk on paper
Van Gogh Museum, Amsterdam
Vincent van Gogh Foundation
Cat. 23

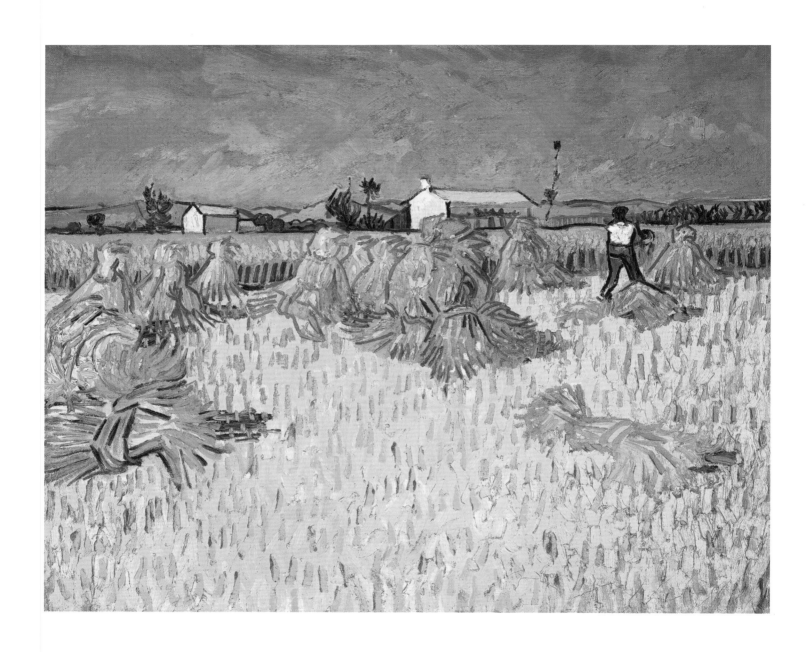

Vincent van Gogh

Corn Harvest in Provence

17–23 June 1888
Oil on canvas
The Israel Museum, Jerusalem
Cat. 24

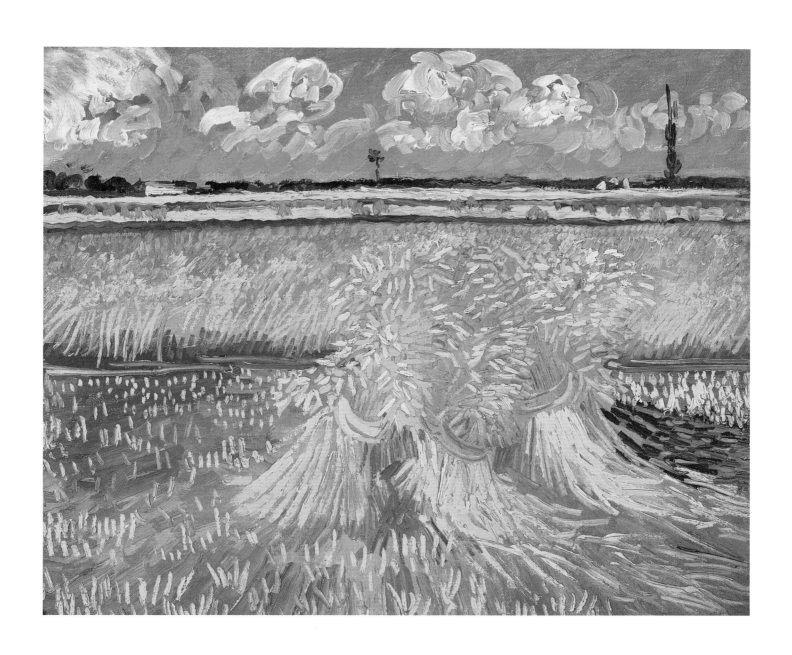

Vincent van Gogh

Wheat Field

17–23 June 1888
Oil on canvas
Honolulu Academy of Arts
Cat. 25

Vincent van Gogh

The Harvest

c. July 1888
Pen and brown ink over graphite
National Gallery of Art, Washington, D.C.
Cat. 26

Vincent van Gogh

Arles: View from the Wheatfields

6–8 August 1888
Reed, quill pens, and brown ink
The J. Paul Getty Museum, Los Angeles
Cat. 27

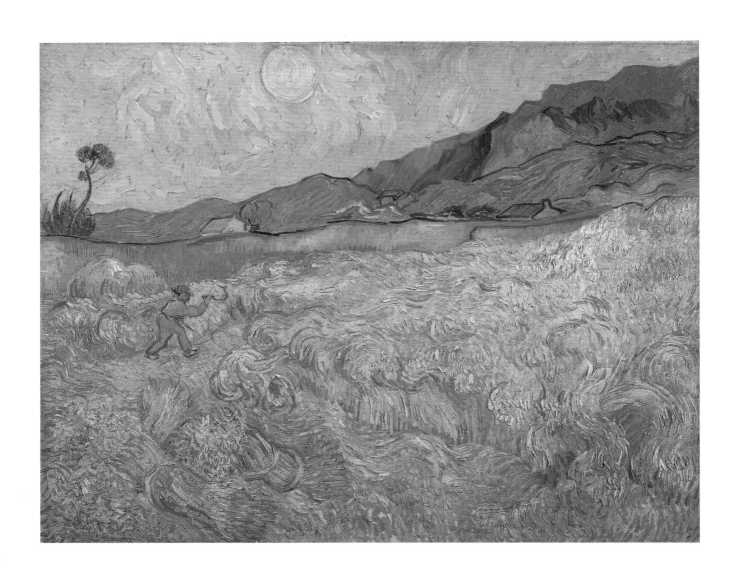

Vincent van Gogh

Wheat Field with a Reaper

5–6 September 1889
Oil on canvas
Van Gogh Museum, Amsterdam
Vincent van Gogh Foundation
Cat. 28

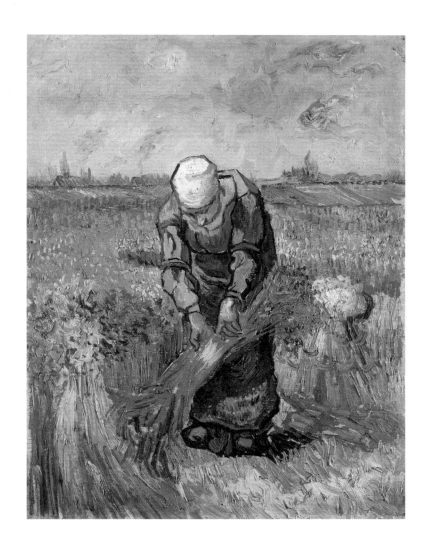

Vincent van Gogh (after J.-F. Millet)

Peasant Woman Binding Sheaves

First half of September 1889
Oil on canvas
Van Gogh Museum, Amsterdam
Vincent van Gogh Foundation
Cat. 29

37

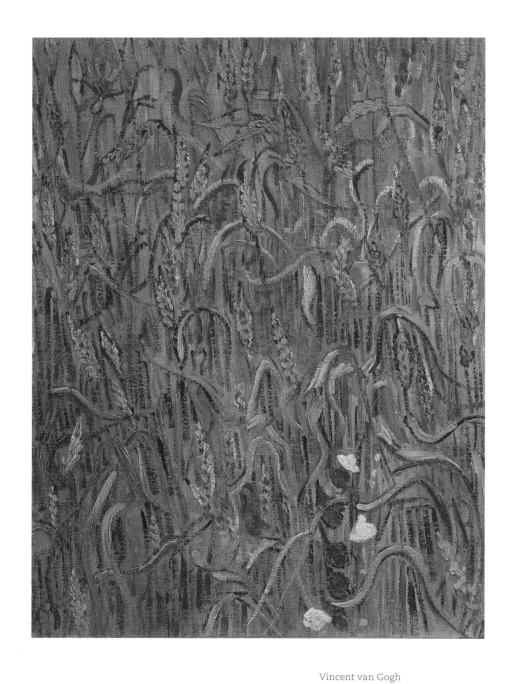

Vincent van Gogh

Ears of Wheat

June 1890
Oil on canvas
Van Gogh Museum, Amsterdam
Vincent van Gogh Foundation
Cat. 30

Vincent van Gogh

Women Crossing the Fields

July 1890
Oil on paper
Collection of the McNay Art Museum, San Antonio,
Bequest of Marion Koogler McNay
Cat. 32

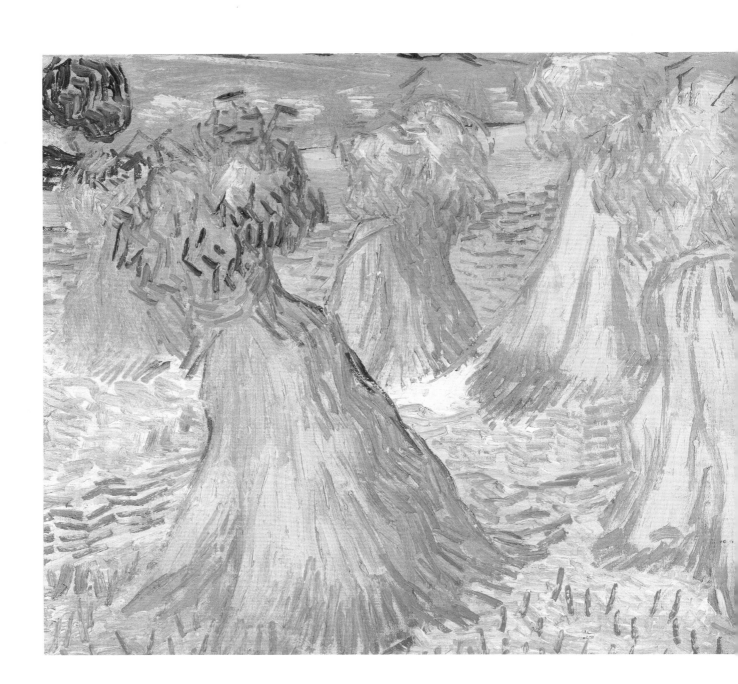

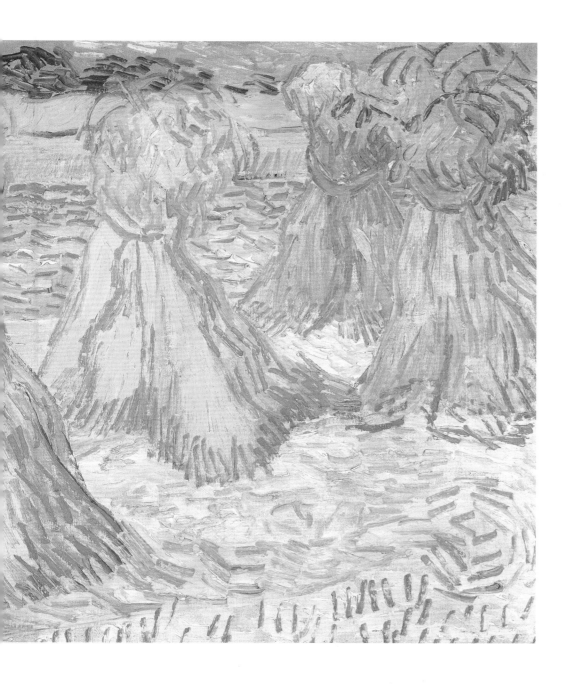

Vincent van Gogh

Sheaves of Wheat

July 1890
Oil on canvas
Dallas Museum of Art, The Wendy and Emery Reves Collection
Cat. 31

41

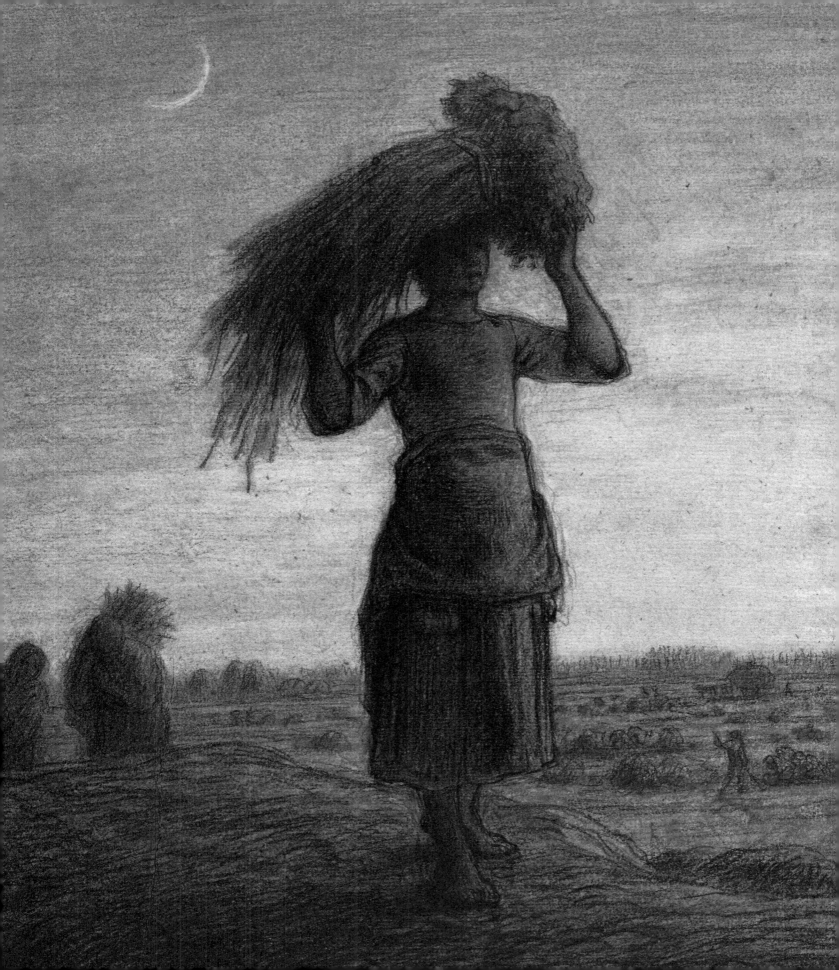

Bradley Fratello

Standing on Holy Ground
Van Gogh, Millet, Symbolism, and Suicide

Vincent van Gogh was overwhelmed when he saw Jean-François Millet's work at the artist's estate sale in Paris in the spring of 1875. Comprising 273 paintings, drawings, and pastels, the sale displayed Millet's oeuvre in all its breadth, but the graphic works seem to have made the greatest impression on the young Van Gogh, then an apprentice art dealer at Goupil & Cie. He wrote his brother Theo: "When I entered the hall of the Hôtel Drouot, where [the drawings] were exhibited, I felt like saying, 'Take off your shoes, for the place where you are standing is Holy Ground.'"[1] Van Gogh's love for Millet's art, then, preceded by years his aspiration to become a painter, and would shape his artistic vision through his final days at Auvers.

The "holy ground" that Van Gogh found in Millet's drawings manifests itself throughout the younger artist's work, and though many of the thematic and compositional cues he took from Millet have been identified,[2] he owed more to the Frenchman than has yet been noted. The Millet drawings he praised in 1875 played an important role in shaping his spiritually infused images of cultivated landscapes and rural peasants, offering him key lessons that would lead him ultimately to his symbolist breakthrough at Arles in 1888–89 and to his final paintings, such as the Dallas *Sheaves of Wheat*.

By early 1874, over a year before the estate sale, Vincent had already confessed to Theo his unbounded admiration for a then little-known Millet painting (fig. 1): "Yes, that picture by Millet, *The Angelus*, that is it—that is beauty, that is poetry."[3] While Van Gogh would not formally devote himself to a life as an artist until July 1880, at that time he immediately turned again to Millet's work—this time for instruction. He copied several of the older artist's paintings, among them *The Angelus*, before the year's end (fig. 2). Depicting a peasant couple reciting the evening prayer of thanks over a basket they have filled with potatoes, *The Angelus* reveals Millet at his most religious and nostalgic. In its romantic pastel sunset and pious rustic subjects it exhibits neither the formal innovations nor the critical attitude toward modern farming practices considered the hallmarks of Millet's contribution to modern art.[4] The painting

FIG. 1

Jean-François Millet, *The Angelus*,
1857–59. Oil on canvas. Musée
d'Orsay, Paris

FIG. 2

Vincent van Gogh (after J.-F. Millet),
The Angelus, 1881. Black chalk, pencil,
washed, red chalk, heightened with white,
on laid paper. Collection Kröller-Müller
Museum, Otterlo, Netherlands

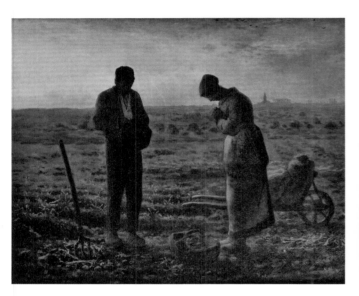

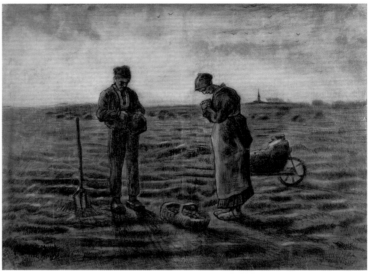

instead presents an edifying image of the hard, simple lives of French peasants, untouched by the rise of profit-driven agribusiness.[5] Given Vincent's upbringing as a reverend's son and his own attempt in the late 1870s at the ministerial calling, it is not surprising that the subject would appeal to him.

It is unlikely, although not impossible, that Vincent saw *The Angelus* before he drew his copy of it, but he did own an engraving of the painting by Martinez (fig. 3).[6] And while in these earliest days of his artistic career Vincent turned to Millet's work for guidance, his drawing of *The Angelus* shows transformations of whichever original he began with—Millet's or Martinez's. Though the figures, their tools, the basket of potatoes, and the church have all been faithfully recorded, the field differs markedly from those depicted by his predecessors. Millet rendered a deeply rutted expanse littered with thorny briars, from which his two peasants have dug the crop. Martinez's thickly engraved lines obscure some of the thorns, but a few remain in the foreground between the figures. In Van Gogh's drawing, the prickly thorns have disappeared entirely, and a vast stretch of rich soil, its furrows rounded like low waves on a gently blown pond, fails to convey the difficulty of the labor that has taken place. As pastoral as Millet's *The Angelus* is, Van Gogh's copy is positively idyllic, even Edenic. By eradicating indications of work, he gave the image pre-lapsarian connotations: a blessed, sinless couple reaping nature's bounty without toil.

Some of Van Gogh's early drawings of stooping women binding and carrying sheaves of wheat acknowledge Millet's best-known work, *The Gleaners* of 1857 (for an etching, see cat. 39, p. 85). This image has been universally characterized as one of Millet's sharpest critiques of modern agribusiness's evisceration of "traditional" rural communities.[7] Isolated from the other field hands in the distance, the gleaners scrape together with bloodied knuckles the clumps of wheat to the right, too meager to qualify as sheaves. The painting offers an unflinching look at the brutality of farm life in the modern age.

The evolution of Millet's *The Gleaners* began with studies for one of his early Salon successes, *Harvesters Resting (Ruth and Boaz)* of 1850–53 (cat. 38, p. 84). An updated treatment of the biblical story of Ruth and Boaz, the painting presents a scene of community and inclusion.[8] Millet depicted Ruth, a widowed gleaner working for her own survival and that of her mother-in-law Naomi on the land of Boaz, a wealthy farmer. The artist selected the moment at which Boaz, touched by the young woman's familial loyalty, welcomes Ruth into the fold of his harvesters with an outstretched arm. Millet used gestures and postures to convey the painting's theme, and underscored it in his portrayal of wheat. The discrepancy between Ruth's armful of grain and the seas of wheat into which she is ushered suggests her poverty. Three tall stacks, the nearest of which towers beyond the top of the canvas, articulate the painting's space and create a sheltering backdrop behind the harvesters that contrasts with the void behind Ruth. The wheat offers the workers comfort—cushioning the ground on which they rest—and supports their sickles while they refresh themselves with a drink. Without a doubt, it was Millet's use of the harvest to communicate and intensify the themes of his paintings that led Van Gogh to call him "the voice of the wheat."[9] Van Gogh used the phrase in late May 1890, only weeks before his suicide, when he was painting the series of horizontally oriented *décorations* of which the Dallas *Sheaves of Wheat* canvas forms a vital part.

The Gleaners revisits the biblical story but rejects its comforting message. Here, on a profit-driven farm, nobody rests. On the horizon, wheat stacks rise above harvesters at work under a blazing sun. The benevolent figure of Boaz has been replaced by a foreman on horseback to the right who monitors the productivity of the field hands. Three hunched, faceless peasant women, their skin leathery from exposure, operate far from the abundant harvest policed by the overseer.

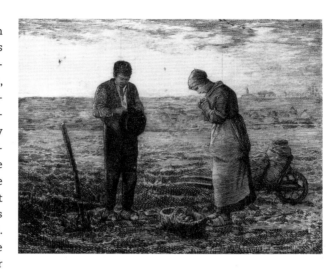

While their poverty may inspire sympathy in viewers, it fails to move anyone within the composition to charity. Théophile Gautier, who detested Millet's unromantic look at rural life in *The Gleaners,* clearly discerned its disavowal of the biblical theme, referring to the "three gleaners advancing in a line, bent toward the ground, collecting in their hands rare, fallen shoots of grain, because some Boaz has not recommended to his harvesters to forget some for these Ruths, who will not be slipping into the tent of the master in the evening."[10]

When he returned to the subject of *The Gleaners* in drawings of stooping and bending women he made at Brabant in the mid-1880s (cat. 14, p. 22; cat. 15, p. 23; cat. 16, p. 24; cat. 17, p. 25), Van Gogh again neglected to demonstrate the older artist's sensitivity to the hardships of the poor. He reduced Millet's iconic poses to quasi-academic studies of the human form at work. Figures and landscape settings—when such settings appear at all—are rendered with vastly differing chalk marks: heavy and dark for figures, wispy and ephemeral for vegetation and soil. Furthermore, in these drawings, the gathered and stacked sheaves contain copious

FIG. 4

Jean-François Millet, *The End of the Day*, 1865–70. Pastel and crayon on paper. Memorial Art Gallery of the University of Rochester, George Eastman Collection of the University of Rochester

FIG. 5

Jean-François Millet, *The Winter Evening*, 1867. Pastel and black conté crayon on gray-brown wove paper. Museum of Fine Arts, Boston. Gift of Quincy Adams Shaw, Jr., and Mrs. Marian Shaw Haughton

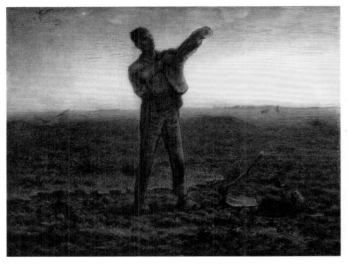

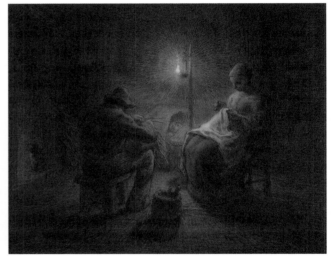

amounts of grain. A letter from Vincent to Theo in the early 1880s provides evidence that Van Gogh understood the resonance of *The Gleaners,* though his drawings register no impulse to reiterate Millet's theme.[11] Griselda Pollock has gone so far as to suggest that in paying unemployed laborers to stoop indecorously in order for him to draw them—sometimes from behind—Van Gogh may have been engaged in a sexually charged form of economic exploitation.[12]

When praising Millet, Van Gogh never stressed the older artist's critical stance toward modern isolation, but emphasized instead his penetrating, spiritual look at rural life. In contrast with two other admired precursors, Eugène Delacroix and Rembrandt van Rijn, Van Gogh asserted that Millet painted "the doctrine of Christ [as opposed to] the figure of Christ."[13] Millet's most biting realist images—painted from the mid-1850s through the early 1860s—may have been his most notorious, but they did not strike Van Gogh as the pinnacle of the older artist's achievement. Instead, Millet became Van Gogh's artistic and spiritual mentor through the comforting, implicitly Christianized pas-

toral tone infused in his last drawings, those that Van Gogh praised to Theo and would see again at a Millet retrospective in 1887. He referred to Millet as "father Millet," with all of that term's paternal and spiritual connotations.[14]

Millet's late pastels and drawings—often depicting dramatic, fleeting sunsets in a heightened palette—are typically seen as his exploration of the impressionists' aesthetic and thematic concerns. Though these shared interests may account for Millet's impact on Gustave Caillebotte, Claude Monet (cat. 45, p. 91), and Camille Pissarro (cat. 46, p. 92; cat. 47, p. 93; cat. 48, p. 94; cat. 49, p. 95), among others, for Van Gogh it was nature's spiritual grandeur that the drawings hinted at. Works on paper by Millet such as *The End of the Day* (fig. 4) and *The Winter Evening* (fig. 5), both of which Van Gogh would copy in 1889–90, certainly capture subtle and fleeting light effects, both natural and man-made, but their power for the younger artist lay in the implicit religiosity of their themes and forms.[15]

The key to understanding the symbolist spirituality of Millet's late pastels is *Resurrection* (fig. 6), a modest

crayon drawing thought to have been part of an unrealized book project. Millet rarely produced explicitly biblical imagery, and *Resurrection* may be among the last such works in his oeuvre. In its directness, it offers insights into the intertwining of thematic and formal characteristics that pervades many of his late drawings—and that moved him beyond the realms of peasant realism and impressionism into symbolism. In the drawing, Christ ascends from the tomb emitting a powerful, blinding nimbus that indicates his triumph over earth and assumption into heaven. Roman soldiers attempt to shield themselves from the vision before them, whose brilliant rays cut through both the earth and the sky and form the principal structural element of the image. Light dominates material forms. The radial aureole occludes the horizon line and flattens space, resulting in an image that renders divinity tangible in a tapestry of earth, flesh, and light.

While the formal affinity between late drawings such as the two mentioned earlier and *Resurrection* has been noted in Millet studies, the thematic connection has not been fully explored.[16] Millet conceived of light not simply as a fleeting optical effect but as an ordering principle. In his drawings, it binds skies to fields. His figures, too, respond to the spiritually charged illumination, their contours shimmering in the glow that envelops them. In his late drawings, Millet conflated the Christian Son with the solar sun, merging nature and faith and expressing the rustic piety he recalled from his youth. Regarding one of Millet's late paintings of his native coastal Normandy, the critic Théophile Silvestre identified this pantheistic quality: "The aspirations of nature and religion come together in this little morsel of painted canvas."[17]

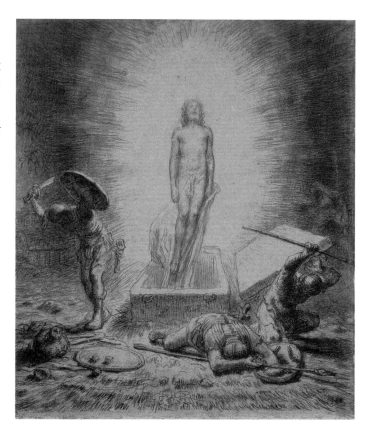

FIG. 6

Jean-François Millet, *Resurrection*, 1863–66. Black conté crayon on wove paper. Princeton University Art Museum. Gift of Frank Jewett Mather, Jr.

FIG. 7

Vincent van Gogh, *The Sower*,
1888. Oil on canvas. Collection
Kröller-Müller Museum,
Otterlo, Netherlands

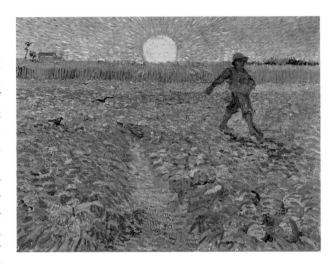

II

As late as April 1888, Vincent claimed to his symbolist colleague Émile Bernard that his "brush stroke [had] no system at all. I hit the canvas with irregular touches of the brush, which I leave as they are."[18] This comment and others, such as those concerning his breakthrough symbolist painting *The Sower* (fig. 7), have led Van Gogh scholars to see Millet as inspiring only Van Gogh's subjects and poses.[19] "Here is the point. The *Christ in the Boat* by Delacroix [see fig. 13, p. 17] and Millet's *The Sower* are absolutely different in execution. The *Christ in the Boat*—I am speaking of the sketch in blue and green with touches of violet, red and a little citron-yellow for the nimbus, the halo—speaks a symbolic language through color alone. Millet's *Sower* is a colorless *gray*."[20] Delacroix's expressive—Van Gogh called it "symbolist"— use of color impressed itself on many late-19th-century artists and art theorists.[21] Bringing it to bear on his own reinterpretation of Millet's "colorless" *Sower* by stacking an explosively yellow sun, sky, and band of wheat stalks over a coarsely tilled field in complementary violets and rich blues, Van Gogh transferred the spiritual charge of Delacroix's religious painting to Millet's rustic peasant theme.

Van Gogh's *The Sower,* however, also includes the strong radial burst of light from a brilliant sun that appears in so many of Millet's late pastel drawings, which the Dutch artist had seen again less than a year before he departed Paris for Arles. Here the force of the setting sun remains in the sky: its rays do not penetrate the field below or filter through the shadows. Nevertheless, the orb's centrality on the flat horizon lends *The Sower* a sense of the geometry and order found in Millet's late work—a feature notably absent in the Delacroix painting. It would appear, then, that the spiritual content of Van Gogh's symbolist painting owed more to Millet than to its subject's biblical resonance.

In fact, this symbolist compositional element, which charges Van Gogh's landscapes and figures with spiritual energy, appears throughout his oeuvre, first in graphic works such as his 1880 drawing *The Angelus*. Here two peasants, their basket of potatoes, a pitchfork, and the furrows in the field all cast shadows into a foreground filled with radial lines that appear nowhere in Millet's painting. The younger artist clearly transposed them from the late drawings to stress the original's devout connotations.

To transfer this compositional feature from a graphic to a painterly medium, something Millet himself did not attempt, was a progression that would take Van Gogh years to complete and can be traced through his images of wheat. Drawings from a two-week period in late August 1885 (cat. 21, p. 29; cat. 22, p. 30; cat. 23, p. 31) depicting groups of wheat sheaves stacked together—aggregates more accurately called "shocks"— demonstrate Van Gogh's experimentation with Millet's bold orthogonal and radial compositions to infuse the landscape with energy. From the same period as the bending women discussed previously, these drawings— which shift focus from figures to the landscape and its

abundance—consistently describe a deeply receding space not found in their counterparts. Shocks of wheat rush dramatically toward a distant horizon on one primary orthogonal line that is reinforced by a second, subtler row of shocks. Van Gogh heightened the dynamism of the cultivated landscape by arranging his implied vanishing points off center, in some cases off the paper entirely. This device lends his works a sense of the infinite, which he often wrote about in mystical terms, "*quelque chose là haut* [something on high], even though I am not sure *how* or *what* it may be."[22]

In these compositions, as well as in a fourth drawing from the same time (cat. 20, p. 28), the shadows of the wheat are formed of clusters of lines arranged radially with an almost centrifugal force. Reminiscent of Millet's handling in his late compositions, the hatch marks composing these shadows both project from the structures that cast them and converge in them. Van Gogh also drew parallels between the strands of grain and the furrowed plains from which they were collected, organically linking harvest and field. In the two most expressive of these drawings, *Wheat Field with Sheaves and Windmill* (cat. 23, p. 31) and *Wheat Field with Reaper and a Woman Binding Sheaves* (cat. 20, p. 28), the energy emitted from the shocks of wheat is almost dizzying: lines in the cultivated soil and shadows literally rush upward, twisting and curling through the harvested grain and exploding through the tops of the stacks like fireworks. Van Gogh rendered the birds, too, like extensions of the wheat dotting the sky, and the peasant workers seem heavy, dull, and plodding by comparison, apparently unaware of their important role in the powerful natural cycles taking place around them.

A single canvas from this period, the Otterlo *Sheaves of Wheat* (cat. 18, p. 26), suggests that Van Gogh remained tentative about translating these bold compositional strategies into the language of paint. In this intimate study of a single shock of wheat, he displays the sensitivity of a portraitist probing the interior world of a compelling sitter. With errant shoots of grain escaping to the right, this beautifully modeled, centered form breaks the horizon while remaining grounded in the field. Despite their compositional assertiveness, Van Gogh's brush strokes appear thin and painstaking when compared to the bold, broad chalk marks in the drawings made at the same time, to say nothing of the strokes he would use in the symbolist paintings of his last years. And while the sheaf of wheat at the front of this shock seems to reach out at its base into the field with a few extended strands, the connection feels timid when compared with what the artist had achieved in his draftsmanship.

In images of wheat fields from that first summer at Arles—when he painted his symbolist version of Millet's *The Sower*—Van Gogh's painting "caught up" to the boldness of his drawings on the same theme. Although produced some four weeks apart, the painting *Wheat Field* (cat. 25, p. 33) and a pen drawing titled *The Harvest* (cat. 26, p. 34) depict the same shock of grain.[23] In the drawing, Van Gogh's marks are uniform and exceptionally confident. His application of paint is equally emphatic. Thick, wide brush strokes are consistent from area to area across the canvas; the clouds are lightly scumbled, the blowing wheat is rendered in thick, parallel diagonal strokes, and the mowed field is shown in short, vertical dashes.

The shock of wheat is contained below the horizon line in both images, and Van Gogh carefully positioned it so the tie continues a horizontal line that distinguishes the edge of the mowed wheat. More fields in the distance, represented by heavy, alternating bands of gold, greens, and blue-greens, divide the heavenly and earthly realms. The format of these two images turns the composition of *The Sower* (fig. 7) and a closely related drawing upside down: the proportions of sky to field remain almost identical, but the complementary

warm and cool tones in the paintings are reversed. Also switched is the position of the compositional vortex. In both *Wheat Field* (cat. 25, p. 33) and *The Harvest* (cat. 26, p. 34), the shock of wheat reaches across the foreground in all directions, giving the lower portion of the composition a center of gravity that bursts into an explosion of husks at the top. In both pairs of images, however, Van Gogh seems to be at pains to prevent this compositional dynamism from crossing the boundary between heaven and earth.

In images of wheat from his final year—from May 1889, when he checked himself into the asylum at Saint-Rémy, through July 1890, when he fatally shot himself at Auvers—Van Gogh fully integrated fields with skies in symbolist compositions in which both colors and brush strokes carry the weight of his spiritual meanings. During his hospitalization, with limited visual resources, the artist turned to prints made after the work of some of his favorite predecessors. In particular, he focused on the copies Lavieille had made of two of Millet's series: *The Labors of the Fields* (cat. 34, p. 79) and *Hours of the Day*. In both series, Millet stressed the cyclical nature of peasant life and the natural world. At this time of emotional crisis, the pious and stalwart Millet that Van Gogh had come to know would have provided him with much-needed consolation.[24]

Van Gogh's "translation" of *Noonday Rest* (fig. 9) from Millet's *Hours of the Day* series (cat. 41, p. 87) demonstrates his success in using brush strokes as well as color to integrate the three primary elements in his image—peasants, their harvest, and the firmament.[25] His sleeping workers are rendered in two types of strokes that establish a gendered code: straight, parallel, diagonal marks in the male figure and sinuous, curving ones in the female. This system recurs in the wheat that surrounds and shades the figures, with "male" strokes used in the tower of grain at their right and "female" in the low-slung piles that cradle them. A sheaf at their feet has anthropomorphic overtones: its proportions and arrangement echo those of the sleeping female laborer, and it is tied at a point that is equivalent to her belted waist. In the distance, two additional stacks of grain are described in shades of gold applied with short, alternating diagonal strokes that extend into the sapphire blue firmament above. No comparable system of marks appears in Millet's image.

Similar associations between figures and their surroundings, which the Millet source only hints at, are reinforced in Van Gogh's reworking of *Peasant Woman Binding Sheaves* (cat. 29, p. 37). Here a single peasant woman in blue bends slightly to tie off a small sheaf of wheat, as she has done so many times already, to add to the diminutive shock behind her to the right. Van Gogh emphasized the paired sets of cuffs at the woman's wrists and elbows far more than Millet did and associated them with similarly exaggerated double ties on the standing sheaves, which are thereby anthropomorphized. As he did with *Noonday Rest,* Van Gogh reworked the source image to create the sense of order he had found in Millet's latest phase. In doing so, he extended the comfort of Millet's "holy ground" to all of Millet's peasant workers, and to himself through one of the darkest periods of his life. "For aren't we, who live on bread, to a considerable extent like wheat, at least aren't we forced to submit to growing like a plant without the power to move . . . and to being reaped when we are ripe, like the same wheat?"[26]

III

Van Gogh scholars disagree on whether Vincent intended to commit suicide when he shot himself in a wheat field on 27 July 1890, and whether his last paintings in any way foreshadow the act.[27] In a letter to Theo in 1882, Vincent mentioned Millet's thoughts on suicide as recorded in Alfred Sensier's biography of the artist:

"It has always seemed to me [Millet] that suicide was the deed of a dishonest man."[28] Reeling from a failed love, Van Gogh tried to take strength from what he called Millet's "manly" example but confessed that on this issue he and the older artist did not see entirely eye to eye: "The unutterable misery within me made me think, Yes, I can understand people drowning themselves. . . . I found strength in the above-mentioned [Millet's] saying, and thought it much better to take heart and find remedy in work."[29] Working through his translations of Millet's paintings at Saint-Rémy, Van Gogh did exactly that. By the end of summer, his doctor declared that Vincent's "thoughts of suicide [had] disappeared, only disturbing dreams remain."[30]

Certainly, he had come to equate the cycles of the harvest with cycles of life, and death was on his mind in his final year. Of *Wheat Field with a Reaper* (cat. 28, p. 36), Vincent wrote to Theo: "I see in this reaper—a vague figure toiling away for all he's worth in the midst of the heat to finish his task—I see in him the image of death, in the sense that humanity might be the wheat he is reaping. So it is, if you like, the opposite of the sower which I tried to do before. But there's no sadness in this death, this one takes place in broad daylight with a sun flooding everything with light of pure gold."[31] Here is a merging of endings and beginnings, as well as humanity and nature, the field of wheat a churning ocean of energy. The tiny, schematic figure of the reaper cuts an odd form against the brightly glowing field, but his sickle—a thick, dark comma of paint—reprises the rhythms of the wheat. Vincent's letter insisted that he remained hopeful in the face of the death he painted, a state of mind suggested by the gleaming yellows and golds he used.

During the autumn at Saint-Rémy, with thoughts of suicide retreating from the forefront of his mind, Vincent spent much of his time reworking Millet's late pastels. That summer, he had written that the wheat, like his work, soothed his mind. "I myself . . . feel obliged to go out and look at a blade of grass, the branch of a fir tree, an ear of wheat, in order to calm down."[32] The oils he completed (fig. 8) restate the radial compositions of Millet's final paintings and the spiritual order they imply.[33] However, when he learned during a visit to Paris at the beginning of July that Theo's finances had deteriorated, Vincent—it has been plausibly speculated—felt that he had been a contributing factor, which may have weighed heavily on him when he returned to Auvers for his final weeks.

The trip to Paris interrupted Vincent's progress on an ensemble of thirteen double-square, horizontally oriented canvases he completed in June and July—including the key Dallas *Sheaves of Wheat* (cat. 31, pp. 40–41). In this work, eight shocks of citron-yellow and gold wheat shimmer in the afternoon sun and cast fresh, lilac shadows to the right. The shadow of a ninth shock reaches in from beyond the canvas's left edge. The space in this painting is confusing. There may be a horizon high in the composition, and if so, the shocks of wheat rise above it, their tops bursting into the golden sky. Above that band of gold, however, vegetation seems to grow as if from a hillside in the deep distance, one that would eradicate any indication of the sky above.

As his letters and earlier related images suggest, Van Gogh's shocks of wheat attain the level of personhood. Here their height and lift, combined with a bright palette—*Sheaves of Wheat* is the most radiant of his final canvases—imbue the painting with the joyousness that he had attributed to *Wheat Field with a Reaper* a year earlier. Joy, however, seems tempered with uncertainty, as is the case in several of the canvases he painted that fateful July. *Roots and Tree Trunks* (fig. 10) presents a similarly ambiguous space and nebulous theme. Do these roots signify life's tenacious hold on the earth, or its fragility and incipient passing? *Crows in the Wheatfield* (fig. 11), often interpreted as Van Gogh's foreshadowing

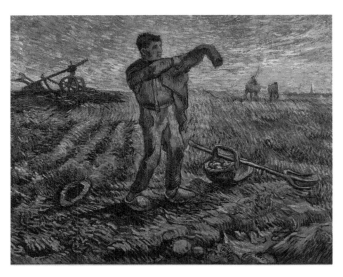

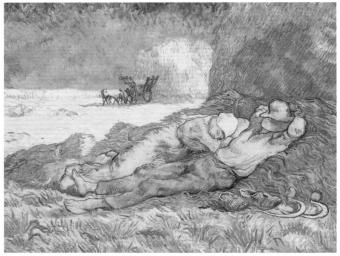

FIG. 8

Vincent van Gogh (after
J.-F. Millet), *End of the Day,*
1889. Oil on canvas. Menard
Art Museum, Aichi, Japan

FIG. 9

Vincent van Gogh (after
J.-F. Millet), *The Siesta,* 1889–90.
Oil on canvas. Musée d'Orsay,
Paris

of his own death, depicts paths through the ears of wheat that seem to stop but may simply disappear from view.[34] If the flock of crows, tightly integrated into the field and the sky, flies toward the picture plane, the birds would seem to suggest the approach of death. If, on the other hand, they recede into the distance, ascension and infinity would be more appropriate readings.[35] The assurance of an indissoluble connection between humankind, nature, and the infinite that he had infused into many of his images of wheat, inspired by Millet's example, appears to have unraveled.

Dallas's *Sheaves of Wheat* lacks the organizational strength of drawings with similar subjects that reflect Van Gogh's adaptation of Millet's comforting compositions (cat. 29, p. 37). The strong orthogonal arrangement of the shocks of wheat he drew in 1885 has faltered: although the elements of this final harvest scene move toward the background from left to right, the rush into the distance that energized the earlier drawings has dissipated. Its presence in another of his horizontal canvases from just the previous month in 1890, *Undergrowth with Two Figures* (fig. 12), makes the absence all

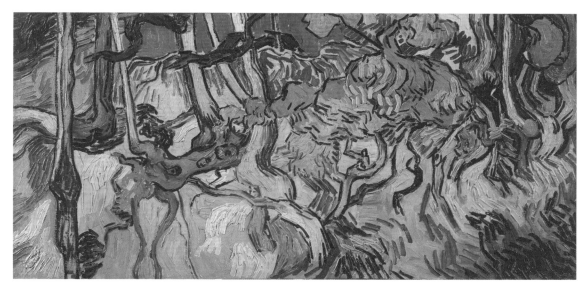

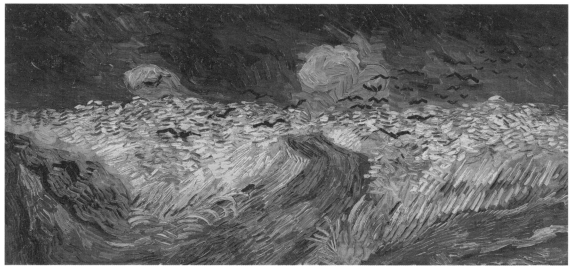

FIG. 12

Vincent van Gogh, *Undergrowth with Two Figures,* 1890. Oil on canvas. Cincinnati Art Museum, Bequest of Mary M. Emery

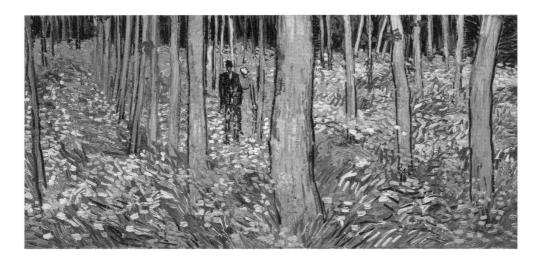

the more evident. Also missing from *Sheaves of Wheat* is the implicit connection between the sheaves and the field. The brush strokes abruptly change color and direction at the base of the shocks, severed from the ground rather than woven into it seamlessly.

Perhaps most disorienting in *Sheaves of Wheat* are the shadows. Although they merge elegantly with the shocks that cast them—their lilac tendrils leading to the right across the field—they shift in direction across the canvas. The centermost shock casts a shadow directly to the right, but to the left, closer to the picture plane, another's shadow falls obliquely into the distance. A small wedge of this shadow appears on the right side of the center shock, touching the base of a sheaf in the middle ground of the painting. And the shadow emerging from the left edge of the canvas, seemingly thrown from a stack of wheat still closer, recedes even more deeply into the middle distance.

Some of Van Gogh's most important last works, then, whether forecasts of suicide or not, suggest deep uncertainty. Bright, garish colors, coupled with inconsistent lighting and ambiguous spatial relations, disrupt the harmony that had come to characterize his symbolist Millet-influenced agrarian paintings. The heroic and heartening model of holy ground that Millet and his art had always offered appears not to have held in Vincent's last days, whether he knew that he had reached the end or not. By July 1890, his emotional burdens had become overwhelming. The ground in Vincent's life and in his paintings, holy or otherwise, appeared to be slipping out from beneath him.

Notes

1. Vincent van Gogh to Theo van Gogh, 29 June 1875. *The Complete Letters of Vincent van Gogh*, 2nd ed., 3 vols. (Greenwich, Conn.: New York Graphic Society, 1959), 1: 28 (29).

2. On Van Gogh's admiration for and use of Millet in his artistic development, see Cornelia Homburg, *The Copy Turns Original: Vincent van Gogh and a New Approach to Traditional Art Practice* (Amsterdam and Philadelphia: John Benjamins, 1996), 79–92; Louis van Tilborgh, ed., *Van Gogh & Millet*, exh. cat. (Amsterdam: Van Gogh Museum, 1989); Louis van Tilborgh and Marie-Pierre Salé, *Millet/Van Gogh*, exh. cat. (Paris: Musée d'Orsay, 1998); and Nienke Bakker, "On Rustics and Labourers: Van Gogh and 'The People,'" in Sjraar van Heutgen, Leo Jansen, and Chris Stolwijk, eds., *Van Gogh's Imaginary Museum: Exploring the Artist's Inner World,* exh. cat. (Amsterdam and New York: Van Gogh Museum in association with Harry N. Abrams, 2003), 87–98. For a recent general study of Van Gogh, containing a select bibliography and chronology of the artist's life, see Judy Sund, *Van Gogh* (London: Phaidon, 2002).

3. Letter from Vincent van Gogh to Theo van Gogh, January 1874. *Complete Letters*, 1: 17 (13). Van Gogh's excited praise of *The Angelus* would seem to suggest that he had seen this then-obscure painting in person, but his letters make no clear mention of such a viewing.

4. T. J. Clark, *The Absolute Bourgeois: Artists and Politics in France, 1848–51* (London: Thames and Hudson, 1973), 72–98; Linda Nochlin, *Realism* (New York: Penguin, 1971), 111–37; and Robert Herbert, *Jean-François Millet*, exh. cat. (London: Arts Council of Great Britain, 1976).

5. On the unequivocally pastoral tone of *The Angelus* as compared to *The Gleaners,* one of Millet's signature "avant-garde" paintings, see Bradley Fratello, "France Embraces Millet: The Intertwined Fates of *The Gleaners* and *The Angelus,*" *The Art Bulletin* 85 (December 2003): 685–701.

6. In a letter to Theo dated 24 March 1873, however, Vincent implied that he had visited Brussels the previous summer, at about the time that *The Angelus* entered the collection of John W. Wilson there. As the representative of an art dealer, Van Gogh may have had access to this well-known Belgian collection—and thus to *The Angelus*—at that time. *Complete Letters*, 1: 4 (29).

7. Along with sources in n. 4, see Robert Herbert, *Millet's 'Gleaners,'* exh. cat. (Minneapolis: Minneapolis Institute of Arts, 1978); Alexandra Murphy, Richard Rand, Brian T. Allen, James Ganz, and Alexis Goodin, *Jean-François Millet: Drawn into the Light*, exh. cat. (Williamstown, Mass.: Sterling and Francine Clark Art Institute, 1999), 72–77. Millet's other most notorious canvas depicting peasant strife with realist cynicism is *Man with a Hoe* of 1863 at The J. Paul Getty Museum in Los Angeles.

8. Herbert, 1976, 80–81; Alexandra Murphy, *Jean-François Millet*, exh. cat. (Boston: Museum of Fine Arts, 1984), cat. no. 39; and Murphy, Rand, Allen, Ganz, and Goodin, 58–59.

9. 25 May 1890. *Complete Letters*, 3: 232 (614a). Van Gogh referred here to the French painter Jules Breton as well.

10. Théophile Gautier, "Salon de 1857," *L'Artiste* 2 (20 September 1857): 35.

11. Van Gogh compared his drawing *Miners' Wives* (1882) to *The Gleaners*: "I again worked on a water color of miners' wives carrying bags of coal in the snow. But especially I drew about twelve studies of figures for it and three heads, and I am not ready yet. I think I found the right effect in the water color, but I do not think it strong enough in character. In reality it is something like 'The Reapers' [*The Gleaners*] by Millet, severe, so you understand that one mustn't make a snow effect of it." *Complete Letters*, 1: 481 (241).

12. Griselda Pollock, "The Ambivalence of the Maternal Body, Re/drawing Van Gogh," *Differencing the Canon: Feminist Desire and the Writing of Art's Histories* (London and New York: Routledge, 1999), 41–63.

13. *Complete Letters*, 3: 495 (8). On Van Gogh's religious beliefs and their impact on his painting, see W. W. Meissner, *Vincent's Religion: The Search for Meaning* (New York: Peter Lang, 1997); for a comparative consideration of the influence of Van Gogh's and Paul Gauguin's religious upbringings on the formation of their mature work, see Debora Silverman, "At the Threshold of Symbolism: Van Gogh's *Sower* and Gauguin's *Vision after the Sermon*," in *Lost Paradise: Symbolist Europe*, exh. cat. (Montreal: Montreal Museum of Fine Arts, 1995), 104–15. Silverman's ideas concerning religion and the art of Van Gogh and Gauguin are given deeper consideration in her *Van Gogh and Gauguin: The Search for Sacred Art* (New York: Farrar, Straus and Giroux, 2000). Her analysis of Van Gogh's *Sower* reappears in expanded, but qualitatively unchanged, form (49–89).

14. 6 July 1882 and 15 August 1882. *Complete Letters*, 1: 395 (212), 438 (225).

15. Despite the lack of a catalogue raisonné of Millet's work or a reconstruction of the contents of important Millet exhibitions held in 1875 and 1877, a perusal of Herbert, 1976, and Murphy, 1984, reveals that at least five works exhibiting what I identify as the artist's symbolist compositional innovation were on display at the estate sale: *Twilight*, 1858–59; *Winter Evening*, 1867; *The Sheepfold by Moonlight*, 1868; *End of the Day*, 1867–69; and *Shepherdess and Flock at Sunset,* c. 1868–70. Two of these, *Twilight* and *End of the Day,* reappeared in Millet's retrospective exhibition of 1887.

16. Herbert, 1976, 154, and Murphy, Rand, Allen, Ganz, and Goodin, 1999, 99–100.

17. "Les aspirations de la nature et de la religion vient ensemble dans ce petit morceau de toile peint." Théophile Silvestre to M. Asselin, 25 February 1871, quoted in Alfred Sensier, *La Vie et l'oeuvre de J.-F. Millet* (Paris: A. Quantin, 1881), 334; and Étienne Moreau-Nélaton, *Millet raconté par lui-même*, 3 vols. (Paris: H. Laurens, 1921), 3: 70.

18. April 1888. *Complete Letters*, 3: 478 (3).

19. Bogomila Welsh-Ovcharov, *Vincent van Gogh and the Birth of Cloisonism*, exh. cat. (Toronto: Art Gallery of Ontario, 1981), 126; Ronald Pickvance, *Van Gogh in Arles*, exh. cat. (New York: Metropolitan Museum of Art in association with Harry N. Abrams, 1984), 102–3; and Silverman, 1995 and 2000. Tilborgh refers to the painting as Van Gogh's attempt "to provide his own contribution to modern art." Tilborgh, 176.

20. 28 June 1888. *Complete Letters*, 2: 597 (503).

21. Nina Athanassoglou-Kallmyer, "Cézanne and Delacroix's Posthumous Reputation," *The Art Bulletin* 87 (March 2005): 111–29.

22. *Complete Letters*, 1: 513 (253).

23. Pickvance, 99–100, 141–42. Pickvance observes the similarities between the Honolulu canvas and the Otterlo *Sower* as well.

24. Leo Jansen, "Vincent van Gogh's Belief in Art as Consolation," in Van Heutgen, Jansen, and Stolwijk, 13–24.

25. Tilborgh, 99–102.

26. 2 July 1889. *Complete Letters*, 3: 456 (13).

27. Naomi Maurer's explication of his final works suggests that she considers a conscious link plausible. Naomi Margolis Maurer, *The Pursuit of Spiritual Wisdom: The Thought and Art of Vincent van Gogh and Paul Gauguin* (Madison: Fairleigh Dickinson University Press, 1998): 111–13. Judy Sund flatly denies the link but acknowledges that the final works "would seem to betray a strained psyche." Sund, 301.

28. Sensier, *La Vie et l'oeuvre*, 229–30.

29. 6 July 1882. *Complete Letters*, 1: 396 (212).

30. Dr. Th. Peyron to Theo van Gogh, 26 May 1889. See http://webexhibits.org/vangogh/letter/20/etc-Peyron-2-Theo.htm.

31. September 1889. *Complete Letters*, 3: 202 (604).

32. 2 July 1889. *Complete Letters*, 3: 456 (13).

33. Tilborgh, 103–10.

34. Sund disagrees with this reading of *Crows in the Wheatfield*, finding the Dallas *Sheaves of Wheat*, with its depiction of the harvest completed, more indicative of life's end. Sund, 297.

35. For synopses of the interpretive dilemmas that *Roots and Tree Trunks* and *Crows in the Wheatfield* present, see Ronald Pickvance, *Van Gogh in Saint-Rémy and Auvers*, exh. cat. (New York: Metropolitan Museum of Art, 1986), 274–76, 282–83. The author's assessment of *Sheaves of Wheat* appears in the same volume (276–77).

Dorothy Kosinski

Of Like Nature
Van Gogh's Precursors and Contemporaries

Though the primary focus of this inquiry is a single painting, *Sheaves of Wheat,* and the artist's lifelong obsession with the symbolic importance of its motif, our broader ambition is to place Van Gogh's production in the context of 19th-century landscape painting. To this end, we include thirty-six paintings and drawings by his precursors and contemporaries dating from 1850 to 1914. Works range in style from realist to academically traditional, from impressionist to neo-impressionist and symbolist. This vast terrain has been explored in the extensive literature devoted to each artist, as well as in the increasingly sophisticated analysis of the meanings of these landscape images within the sociopolitical climate of 19th-century France. This brief introduction serves to indicate the richness of the motif in this period and to offer a sketch of the major ideas and currents of recent scholarship.[1]

A broad focus is particularly appropriate considering the depth and breadth of Van Gogh's knowledge of contemporary art and art history, the curiosity he brought to his travels—especially during his visits to exhibitions and museums—and his voracious reading. Van Gogh knew some of these artists personally and recorded his admiration for them in his copious correspondence. For instance, he once coveted a painting by Charles Angrand, *Feeding the Chickens* (fig. 1), proposing to trade one of his own canvases for it.[2] He repeatedly mentioned Jules Breton and Jean-François Millet, often in the same sentence: "Millet is the voice of the wheat, and Jules Breton too."[3] He wrote of Paul Cézanne's painting *The Harvest* (which Paul Gauguin later owned).[4] At the Musée du Luxembourg, he admired paintings by Breton, Camille Bernier, and Charles-François Daubigny. He seems to have shared the intense contemporary enthusiasm for Breton, praising his prize-winning paintings such as *Benediction of the Wheat at Artois* and *The Return of the Gleaners* (fig. 2, 3).[5] Léon L'Hermitte and Camille Pissarro are other artists who captured his attention.[6] While in Paris, Van Gogh frequently took part in the casual meetings and discussions of avant-garde artists at Henri de Toulouse-Lautrec's studio. Lautrec and Émile Bernard were among his closest friends at that time. He knew

FIG. 1

Charles Angrand, *Feeding the Chickens*, 1884. Oil on canvas. Ny Carlsberg Glyptotek, Copenhagen

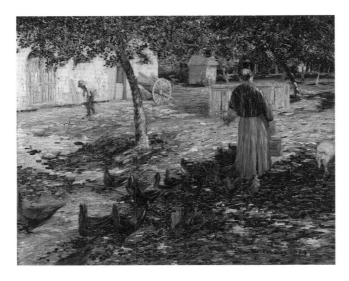

Angrand (cat. 2, p. 65) and was familiar with the work of other artists in the same orbit, including Pissarro (cat. 46, p. 92), Georges Seurat, Paul Signac, and Félix Vallotton. His discussions with Gauguin about a utopian artists' community resulted in their brief, ill-fated sojourn together in Arles in the "Studio of the South."[7]

One aspect of Van Gogh's response to these colleagues, and the focus of the current study, is the artists' shared engagement with imagery of the peasant and labor in the field. These motifs were critical to Van Gogh's self-definition, to his aesthetic-life mission: "Painting peasant life is a serious business, and I for one would blame myself if I didn't try to make pictures that could give rise to serious reflections in those who think seriously about art and life."[8] Van Gogh was not simply extraordinarily earnest about his métier; he wholeheartedly embraced a Christological concept of the artist's function. Small wonder, then, that Alfred Sensier's biography of Millet, which promulgated a mythologized image of his subject's heartfelt identification with the workers' plight and with the redemptive role of the artist, was immensely appealing to Van Gogh.

Van Gogh's aspiration to paint with an authentic voice—"one must paint peasants as if one were one of them, as if one felt and thought as they do"[9]—does not put him in the ranks of a stylistically consistent pantheon of artists. It is, for instance, especially striking how often he mentions Breton and Millet in the same breath. Van Gogh admired Millet's earthy realism—"sale, grossier, boueux" (dirty, coarse, muddy) (cat. 41, p. 87).[10] Yet at the same time, he responded to Breton's statuesque, heroicized peasant women, who seem closer to the model in the studio than to the worker in the field (cat. 7, p. 70). L'Hermitte's gently ennobling sensibility is very different from Millet's Barbizon realism, yet Van Gogh anoints him a second Millet (cat. 35, p. 80).[11] Breton, whose epic peasant paintings were highly celebrated in their time, spawned a younger generation including Julien Dupré whose fieldworkers seem to glide friezelike across the composition (cat. 10, p. 74). Pissarro's grand, almost classicized images of rural labor exemplify that artist's sociopolitical ideology (cat. 48, p. 94). Van Gogh admired them all.

Peasant paintings were enormously popular in the mid- and late 19th century, inspiring a wide variety of artists—academicians and avant-garde practitioners alike—to exploit the marketability of the genre. It seems entirely plausible that Van Gogh, buffeted by financial worries and deeply concerned by the burden he presented to his brother Theo, would have admired Breton for his sheer success.[12] However, this in no way contradicts the resonance Breton's images of the plentitude of the harvest would have had with Van Gogh's deeply held notions of the cycles of nature and human life as revealed in the labor of the peasants in the field. Similarly, because of his profound empathy for the worker, Van Gogh might well have also been receptive to the political readings that swirled around the ennobling visions of the peasant.[13] The bourgeoisie would have interpreted these depictions as emblems of stability

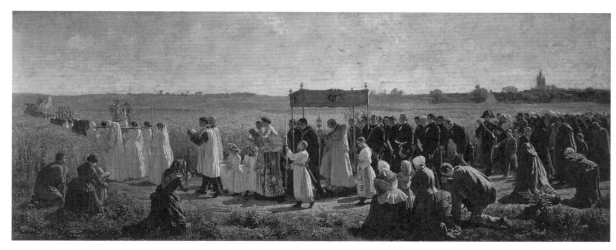

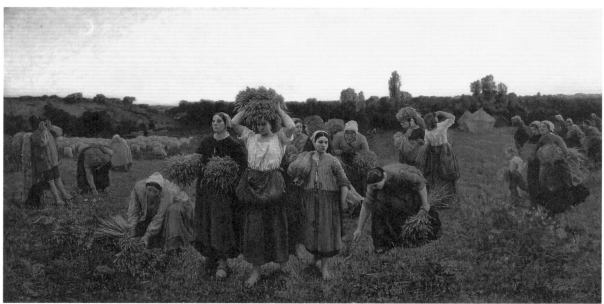

during times of radical change. The government of the Third Republic could manipulate them as symbols of the aspirations of modern France.[14] The appeal to the bourgeois collector's nostalgia and political conservatism is clear: the heroic peasant is a soothing image of an agrarian ideal that was threatened by a multitude of factors, including massive migrations from the land to the capital, the breakdown of structures of landownership, and the introduction of new farming techniques.[15] Though Van Gogh was by no means immune to these concerns, the "consolation" that he found in nature and the simple life of the peasant probably had more to do with the refuge he sought from his personal psychological and spiritual tumult.

For Van Gogh, landscape not only provided a subject for the expression of his inner life and his apprehension of abstract principles in nature, but also served—as it did for other avant-garde artists—as a vehicle for the investigation of new pictorial techniques. Landscape constituted a neutral subject for experimentation with the languages of modernism.

The interest in landscape follows the trajectory of impressionism, which was quintessentially an art about the perception and depiction of the natural world, with only early and limited focus on the figure. Claude Monet's paintings of the *meullettes,* or small haystacks, at Giverny reveal his interest in the "moment," the "atmospheric envelope" that led him increasingly to work with select motifs in nature, painted often in series so as to capture most accurately rapid variations in light and weather (cat. 45, p. 91). Subsuming the subject in almost metaphysical concerns, Monet in his long career shifted from naturalism to symbolism, from the objective to the subjective.

Angrand, too, moved away from impressionism (cat. 1, p. 64), sharing with Henri Cross, Maximilien Luce, Seurat, and Signac a fascination with pointillist technique and the investigation of optical effects of the division of tone, color, and light that Gauguin explored in the remote villages of Brittany with a non-illusionist style he termed "synthetist" (cat. 13, p. 77). In Bernard's view of a Breton seaside harvest in Saint-Briac, it is the broad rhythmic patterns integrating the elegant silhouettes of the people with the undulating forms of the landscape that dominate rather than any exploration of toil (cat. 3, p. 66). In his synthetist-inspired late landscapes, the Swiss Nabi Félix Vallotton manipulates extremely refined and reductive surface patterning, constructing pictorial equivalents of forms in nature (cat. 52, p. 98).

The tension between city and country is a crucial theme in the current discussion. Many of the artists under consideration went to Paris to study, yet their depictions of sheaves of wheat are evidence of the competing lure of the rural environment, the attraction of the purported purity and salubrious simplicity of village life. This phenomenon is consistent with the political, social, and economic crises that enveloped France in the second half of the 19th century. Already at mid-century, realist artists including Millet took refuge in the village of Barbizon near the Forest of Fontainebleau. Théodore Rousseau wandered to even more obscure spots—Landes, the Sologne, and Berry— in search of the untouched landscape.[16] As discussed elsewhere in this publication, Van Gogh and many artists of his generation looked to Millet, responding in part to a fiction forged principally by Sensier, but also promoted by Millet himself, that attempted to establish his authenticity as a peasant painter. As the urban center expanded and the village of Barbizon was no longer so remote, it was Millet's native Normandy that was invoked, sometimes as mediated by travel guides and popular prints.[17] Just as Monet had abandoned Paris for sites along the Seine—Argenteuil, Vétheuil, Poissy, and finally Giverny—Bernard and Gauguin were drawn to hidden nooks of Brittany in their search for local

FIG. 4

Artist unknown (after J. J. van der
Maaten), *Funeral Procession through
a Wheat Field,* 1862. Engraving.
Universiteitsbibliotheek, Amsterdam

dialects and "primitive" traditions.[18] The Swiss painter Ernst Biéler withdrew to the Savièse, a remote rocky area near Martigny in the Canton du Valais (cat. 4, p. 67). His depictions of peasant life in isolated villages are consonant with the highly self-conscious primitivized style he adopted. Monet's Giverny emerged as a mecca for artists from France and elsewhere. American Louis Paul Dessar, who joined the many foreigners studying at the Académie Julian in Paris, spent time in Giverny in 1891–92 (cat. 9, pp. 72–73). Pissarro lived in the countryside in Éragny, where the labors of the peasants in the fields were his primary focus (cat. 49, p. 95).

The flight from the city often involved nostalgia for an idealized past in which the French peasant is highly romanticized, removed from both historic truth and contemporary social and economic realities. The sheaves of wheat are, then, symbols of longing, emblems of an era passed, images of a timeless fiction. Robert Zünd's exquisitely beautiful mid-century *Harvest* (cat. 55, p. 101), for instance, suggests notions of the eternal bounty of nature while stylistically embracing the grand tradition of landscape as embodied in the works of Claude Lorrain. It presents an image of the biblical "land of milk and honey" rather than identifying an actual place. It is therefore all the more startling to discern a modern threshing machine in Gabriel Rigolot's massive 1893 Salon painting (cat. 50, p. 96). It was precisely this type of equipment that transformed the process of harvesting by hand, disrupting the traditional roles of the farmworkers. Visible in the background of Lucien Simon's 1913 painting (cat. 51, p. 97) is another new harvesting machine that hints at the changing realities of contemporary life, a departure from his earlier celebrations of Breton peasantry.[19]

Printmaking played a critical role in the dissemination and popularization of the image of the peasant at work with wheat in the fields. Van Gogh adamantly advocated the wide distribution of prints: "How I wish there were more good reproductions after Millet; that way some would end up in the hands of the people."[20] During his hospitalization in Saint-Rémy, Van Gogh based his painted copies on Jacques-Adrien Lavieille's engravings of Millet's *The Labors of the Fields* (cat. 29, p. 37; cat. 34, p. 79). In a letter to Theo during his earliest days in Paris, he described the many prints and reproductions hanging in his tiny Montmartre room— images by Rembrandt van Rijn, Jean-Baptiste-Camille Corot, Constant Troyon, Dupré, Millet, and Daubigny, among others.[21] Van Gogh expressed his admiration for L'Hermitte's charcoal drawings, calling him the "Millet and Jules Breton of black and white."[22] L'Hermitte, a naturalist painter, frequently submitted illustrations for a variety of books and magazines; like Daubigny, he remained a prolific printmaker throughout his career. Angrand, Pissarro, and Vallotton are among the avant-garde artists who contributed to Jean Grave's anarchist journal *Les Nouveaux Temps*. One must not forget that Pissarro's *The Harvest* for his series *The Labors of the Fields* expresses his enduring interest in scenes of rural labor and also his anarchist reform politics (cat. 48, p. 94). Among the masterworks of modern printmaking are

61

Gauguin's 1889 lithographs on zinc *The Pleasures of Brittany* (cat. 12, p. 76). In their Breton subject matter but also in the roughness of the particular printmaking technique, these works are infused with the nostalgic notions of rustic simplicity that, as discussed above, many of the artists brought to the subject of the peasant at work and the wheat harvest.[23] One print that was particularly crucial throughout Van Gogh's lifetime was J. J. van der Maaten's *Funeral Procession through a Wheat Field,* 1862 (fig. 4). Though it hung on the wall of his Montmartre room, he had known it much earlier. His father had owned it, and he himself had annotated a copy. The image, often invoked by the Dutch Protestant clergy, shows a reaper with the scythe, a broad swath of sky, and a church in the background, all essential elements in Van Gogh's mature compositions; but even more importantly, the composition nurtured his evolving understanding of the parallels between the cycles of sowing and harvest and the inexorable rhythm of life and death.[24]

Notes

1. This brief introduction will offer a selected bibliography of the important literature on the subject of agrarian imagery and the landscape of 19th-century France. On the juxtaposition of the avant-garde and the academic, see Gabriel Weisberg, *The Realist Tradition: French Painting and Drawing 1830–1900*, exh. cat. (Bloomington: Indiana University Press, 1980). For a discussion of the social and cultural factors that had an impact on landscape painting in France in the last twenty-five years of the 19th century and into the 20th up to World War I, see Richard Thomson, *Landscape Painting in France, 1874–1914*, exh. cat. (Edinburgh: National Gallery of Scotland, 1994). For an analysis of how the whole idea of nature—the experience and understanding of the countryside—was invented anew as the result of an evolving urban and middle-class culture in the 19th century, see Nicholas Green, *The Spectacle of Nature: Landscape and Bourgeois Culture in Nineteenth-Century France* (Manchester: Manchester University Press, 1990). In terms of England and the historical, social, and ideological factors that shaped the production and reception of agricultural images, see Christina Payne, *Toil and Plenty: Images of the Agricultural Landscape in England, 1780–1890*, exh. cat. (New Haven and London: Yale University Press, 1993).

2. Han van Crimpen and Monique Berends-Albert, eds., *De brieven van Vincent van Gogh*, 4 vols. ('s Gravenhage: SDU, 1990). For an English translation of the portion of the letter in which Van Gogh discusses Angrand, see Sjraar van Heugten, Leo Jansen, and Chris Stolwijk, eds., *Van Gogh's Imaginary Museum: Exploring the Artist's Inner World*, exh. cat. (Amsterdam and New York: Van Gogh Museum in association with Harry N. Abrams, 2003), 267.

3. *The Complete Letters of Vincent van Gogh*, 2nd ed., 3 vols. (Greenwich, Conn.: New York Graphic Society, 1959), 3: 232 (614a). Bradley Fratello's essay "Standing on Holy Ground: Van Gogh, Millet, Symbolism, and Suicide" in the current publication adds to the copious literature concerning the artist's aesthetic and psychological affinity with Millet. Other major studies of Van Gogh and Millet are Nienke Bakker, "On Rustics and Labourers: Van Gogh and 'The People,'" and Roelie Zwikker, "Van Gogh's Teachers," in Van Heugten, Jansen, and Stolwijk, 37–48, 87–98; Judy Sund, *True to Temperament: Van Gogh and French Naturalist Literature* (Cambridge, England: Cambridge University Press, 1992); and Louis van Tilborgh, Sjraar van Heugten, and Philip Conisbee, *Van Gogh & Millet*, exh. cat. (Zwolle: Waanders b.v.; Amsterdam: Rijksmuseum Vincent van Gogh, 1989).

4. See Merete Bodelson, "Gauguin's Cézannes," *The Burlington Magazine* (May 1962): 204–11, and *Complete Letters*, 2: 583 (497).

5. *Complete Letters*, 1: 41 (42).

6. Ibid., 2: 350 (395), 590 (500).

7. For a detailed discussion of Gauguin and Van Gogh's collaboration in Arles, see Douglas W. Druick and Peter Kort Zegers, *Van Gogh and Gauguin: The Studio of the South*, exh. cat. (New York: Thames and Hudson; Chicago: Art Institute of Chicago; Amsterdam: Van Gogh Museum, 2001).

8. *Complete Letters*, 2: 371 (404).

9. Ibid.

10. Ibid.

11. Ibid., 2: 277 (362).

12. Breton's *The Return of the Gleaners* (1859) was purchased at the Salon by the emperor Napoleon III, who later, in 1862, had it displayed at the Musée du Luxembourg. Weisberg, 86.

13. For particularly insightful discussions of the reception of Jules Breton's peasant paintings, see Robert J. Bezucha, "The Urban Vision of the Countryside in Late-Nineteenth-Century French Painting: An Essay on Art and Political Culture," and Hollister Sturges, "Jules Breton: Creator of the Noble Peasant Image," in *The Rural Vision: France and America in the Late Nineteenth Century*, exh. cat (Omaha: Joslyn Art Museum, 1987), 13–21 and 23–41, respectively.

14. See the essays by Louis Bergeron, Gabriel Weisberg, Geneviève Lacambre, and Patrick Descamps in Descamps, ed., *Des Plaines à l'usine: Images du travail dans la peinture française de 1870 à 1914*, exh. cat. (Paris: Somogy Éditions d'Art, 2001).

15. On the reality of the peasant's life in relation to economic change and its impact on social relations and institutions, see Roger Price, *A Social History of Nineteenth-Century France* (New York: Holmes and Meier, 1987), 143–92.

16. On Théodore Rousseau and his travels, see the entry by Dorothy Kosinski in *Bonjour, Monsieur Courbet!: The Bruyas Collection from the Musée Fabre, Montpellier*, ed. Sarah Lees, exh. cat. (Paris: Éditions de la Réunion des Musées Nationaux, Williamstown, Mass.: Sterling and Francine Clark Art Institute, 2004), 222–29. See also Greg M. Thomas, *Art and Ecology in Nineteenth-Century France: The Landscape of Théodore Rousseau* (Princeton: Princeton University Press, 2000).

17. See Maura Coughlin, "Millet's Milkmaids," *Nineteenth-Century Art Worldwide*, vol. 2 (winter 2003), http://www.19thc-artworldwide.org/winter_03/articles/coug.html (accessed 29 December 2005). See also her thesis "The Artistic Origins

of the French Peasant Painter: Jean-François Millet; Between Normandy and Barbizon" (Ph.D. diss., New York University, Institute of Fine Arts, 2001). See Bradley Fratello's discussion of nostalgia and the longing for the past, which informs particularly Millet's image of the sower, in "Footsteps in Normandy: Jean François Millet and Provincial Nostalgia in Late-Nineteenth-Century France," in Frances Fowle and Richard Thomson, eds., *Soil and Stone: Impressionism, Urbanism, Environment* (Aldershot: Ashgate, 2003). Richard Thomson aptly cites early investigations of this notion of city vs. country in his introduction to Robert Herbert, "City vs. Country: The Rural Image in French Painting from Millet to Gauguin," *Artforum* 8 (February 1970): 44–55; see also Richard Brettell, Sylvie Gaché-Patin, Françoise Heilbrun, and Scott Schaefer, *A Day in the Country: Impressionism and the French Landscape*, exh. cat. (Los Angeles: Los Angeles County Museum of Art, 1984).

18. See Magdalena Dabrowski, *French Landscape: The Modern Vision 1880–1920*, exh. cat. (New York: Harry N. Abrams, 1999); Dabrowski discusses the various regions of France that became the focus for travel and tourism.

19. For a presentation of the realities of change in rural life, see Eugen Weber, *Peasants into Frenchmen: The Modernization of Rural France, 1870–1914* (Stanford: Stanford University Press, 1976). Weber discusses the introduction of the noble grain—wheat—in the stead of rye; the impact of fertilization; the use of sickles even after the introduction of the more efficient scythe; and the resistance to modernization in many rural areas.

20. *Complete Letters*, 3: 194 (600).

21. Ibid., 1: 29 (30).

22. Ibid., 3: 347 (20).

23. Robert Herbert makes this point when revisiting his earlier pioneering work concerning the yearning for a rural way of life during a period of dramatic modernization in *Peasants and "Primitivism": French Prints from Millet to Gauguin*, exh. cat. (South Hadley, Mass.: Mount Holyoke College Art Museum, 1995). This catalogue's focus on prints addresses the popularity of that medium and its role in the dissemination of images of rural labor to a broad public.

24. On the importance of Van Gogh's Van der Maaten print in his art and spirituality, see Joan Greer, "'Christ, This Great Artist'—Van Gogh's Socio-Religious Canon of Art," in Van Heugten, Jansen, and Stolwijk, 67–71. Tsukasa Kōdera, *Vincent van Gogh: Christianity versus Nature* (Amsterdam and Philadelphia: John Benjamins, 1990), 3–18.

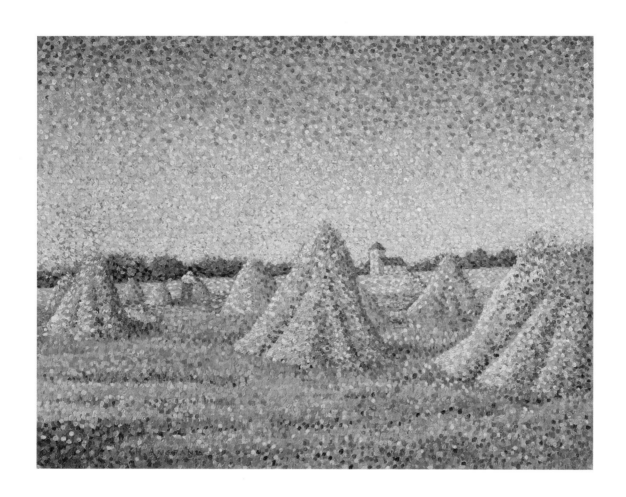

Charles Angrand

Harvest

c. 1887
Oil on canvas
Association des Amis du Petit Palais, Musée d'art
moderne, Geneva
Cat. 1

Charles Angrand

End of the Harvest

1890s
Conté crayon
The Cleveland Museum of Art
Cat. 2

Émile Bernard

Harvest near the Seaside

1891
Oil on canvas
Musée d'Orsay, Paris
Cat. 3

Ernst Biéler

Plaiting Straw

1906–07
Watercolor on paper glued to canvas
Musée Cantonal des Beaux-Arts de Lausanne
Cat. 4

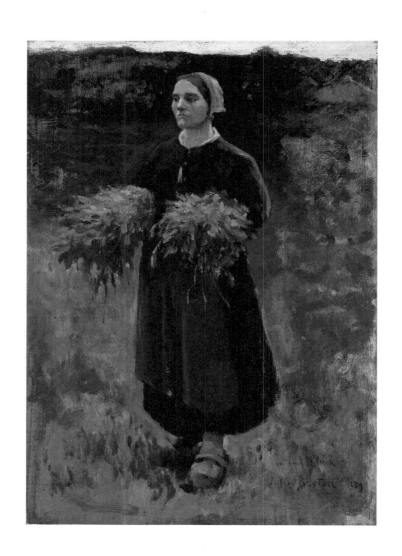

Jules-Adolphe-Aimé Louis Breton

The Gleaner

1859
Oil on board
The Museum of Fine Arts, Houston
Cat. 5

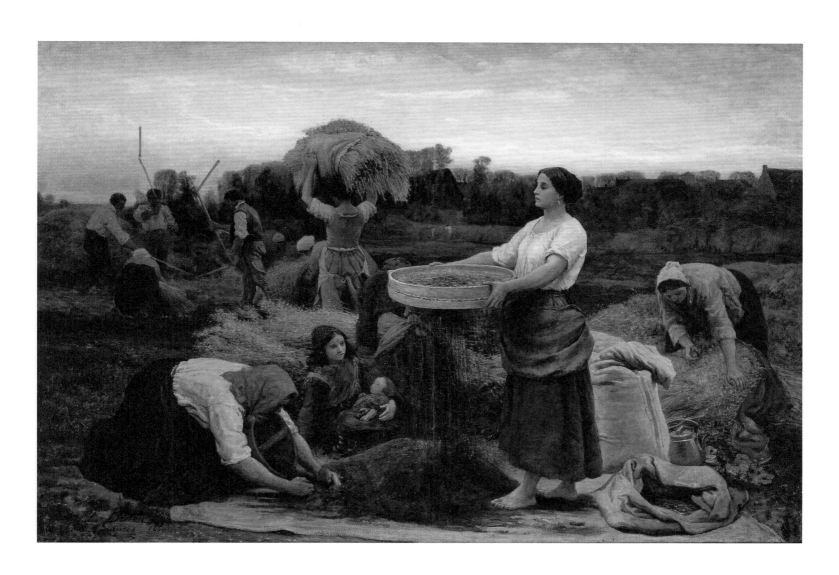

Jules-Adolphe-Aimé Louis Breton

Le Colza (The Rapeseed Harvest)

1860

Oil on canvas

In the collection of The Corcoran Gallery of Art,
Washington, D.C.

Cat. 6

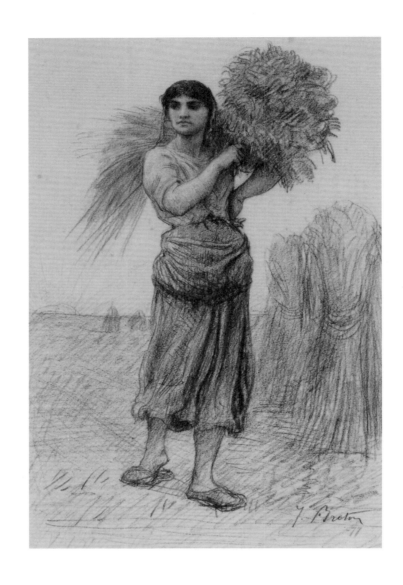

Jules-Adolphe-Aimé Louis Breton

The Gleaner

1877
Black chalk and pencil on paper
The Snite Museum of Art, University of Notre Dame,
Indiana
Cat. 7

Charles-François Daubigny

Summer Landscape

n.d.
Oil on panel
Ateneum Art Museum, Finnish National Gallery, Helsinki
Cat. 8

Louis Paul Dessar

Peasant Woman and Haystacks, Giverny
1892
Oil on canvas
Terra Foundation for American Art, Chicago
Cat. 9

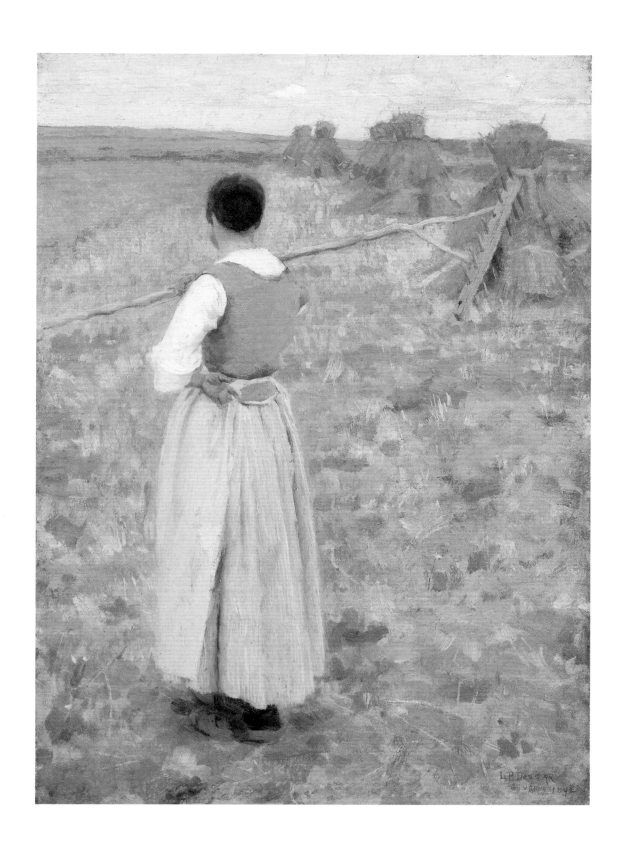

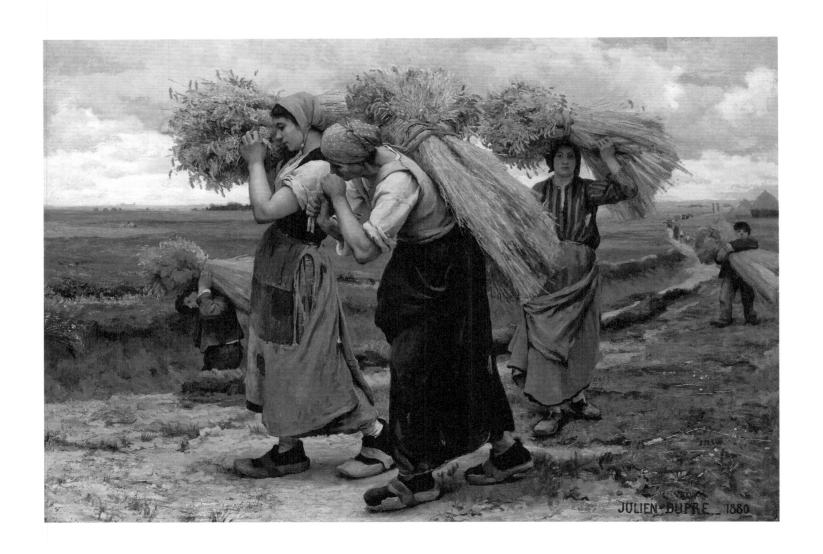

Julien Dupré

The Gleaners

1880
Oil on canvas
Private collection, California
Cat. 10

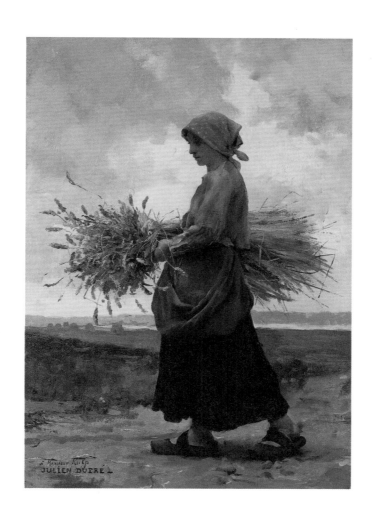

Julien Dupré

Returning from the Fields

n.d.

Oil on canvas

Private collection, Texas

Cat. 11

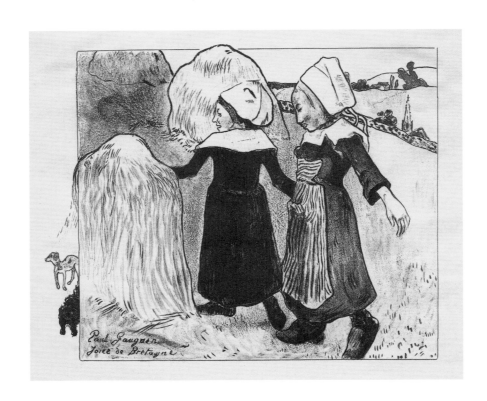

Paul Gauguin

The Pleasures of Brittany

1889
Lithograph on zinc, printed on yellow wove paper
Sterling and Francine Clark Art Institute, Williamstown,
Massachusetts
Cat. 12

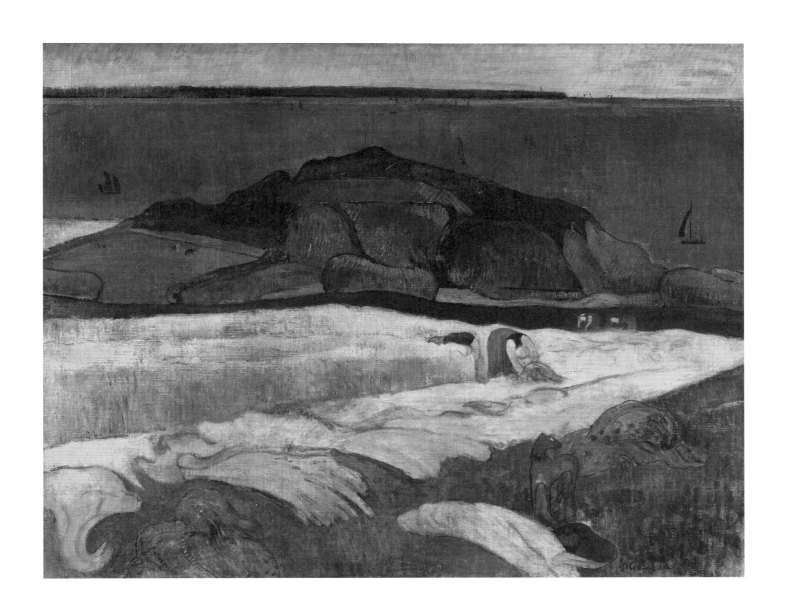

Paul Gauguin

Harvest: Le Pouldu

1890

Oil on canvas

Tate

Cat. 13

Daniel Ridgway Knight

Harvest Scene

1875
Oil on canvas
Chrysler Museum of Art, Norfolk, Virginia
Cat. 33

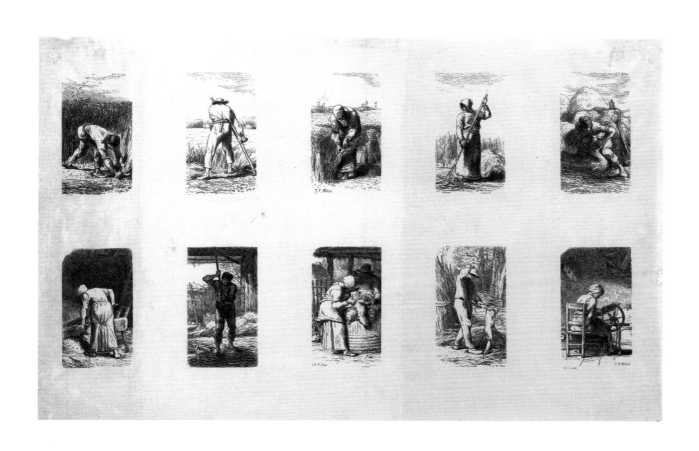

Jacques-Adrien Lavieille (after J.-F. Millet)

The Labors of the Fields

1853
From a series of ten wood engravings
Van Gogh Museum, Amsterdam
Vincent van Gogh Foundation
Cat. 34

Léon Augustin L'Hermitte

Wheatfield (Noonday Rest)

1886
Oil on canvas
Museum of Fine Arts, Boston
Cat. 35

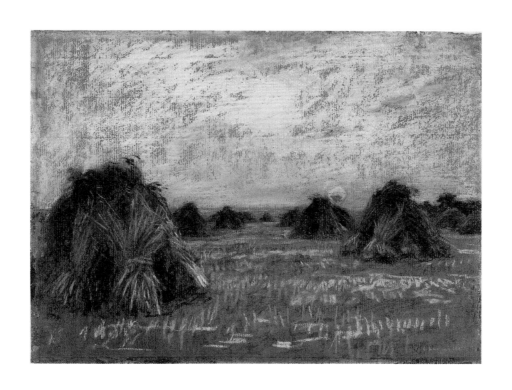

Léon Augustin L'Hermitte

End of the Day

Probably 1887
Pastel on laid paper
Musée des Beaux-Arts, Reims
Cat. 36

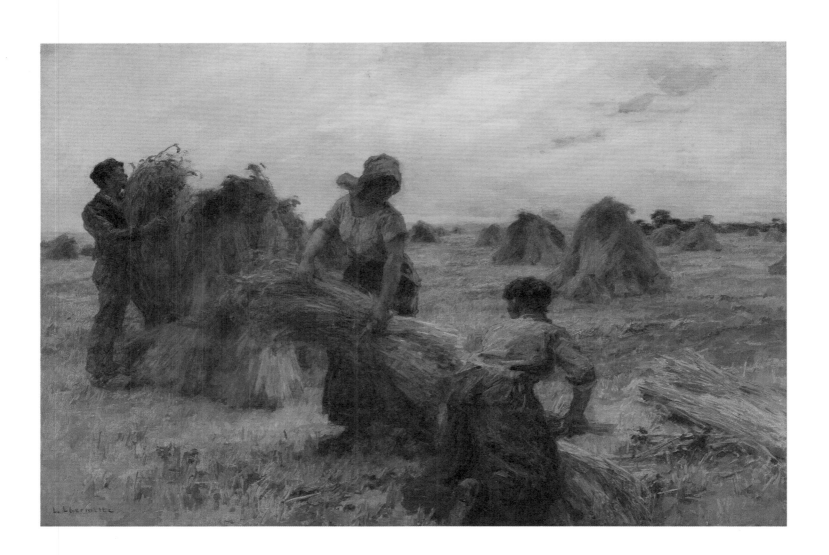

Léon Augustin L'Hermitte

The Harvesters

1888–89
Oil on canvas
The Art Institute of Chicago
Cat. 37

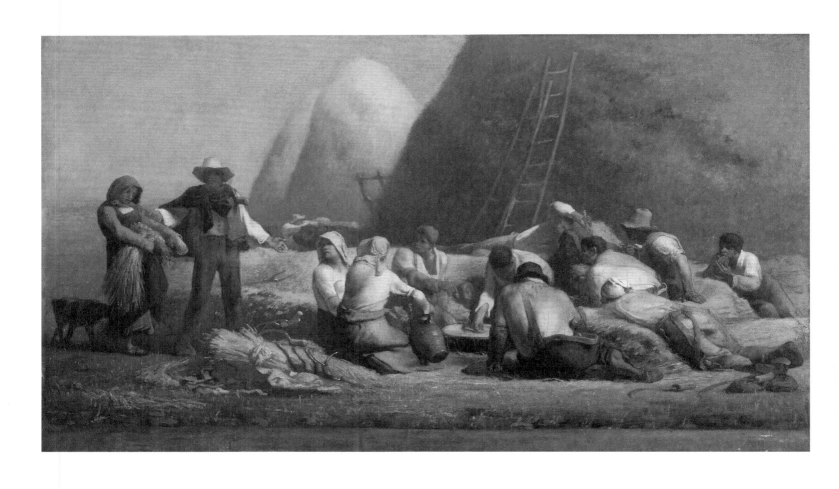

Jean-François Millet

Harvesters Resting (Ruth and Boaz)

1850–53
Oil on canvas
Museum of Fine Arts, Boston
Cat. 38

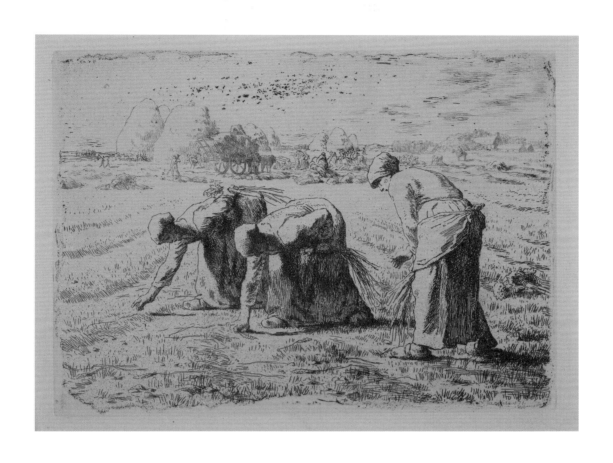

Jean-François Millet

The Gleaners

c. 1855
Etching
Dallas Museum of Art, Bequest of Vera C. Perren
in memory of Mr. and Mrs. Oliver Jackson Perren
Cat. 39

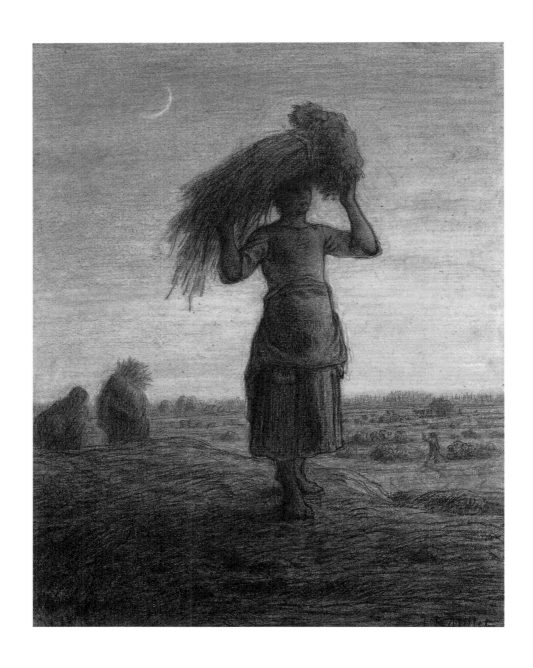

Jean-François Millet

Gleaner Returning Home with Her Grain

c. 1857–62
Black conté crayon on paper
The Frick Art and Historical Center, Pittsburgh
Cat. 40

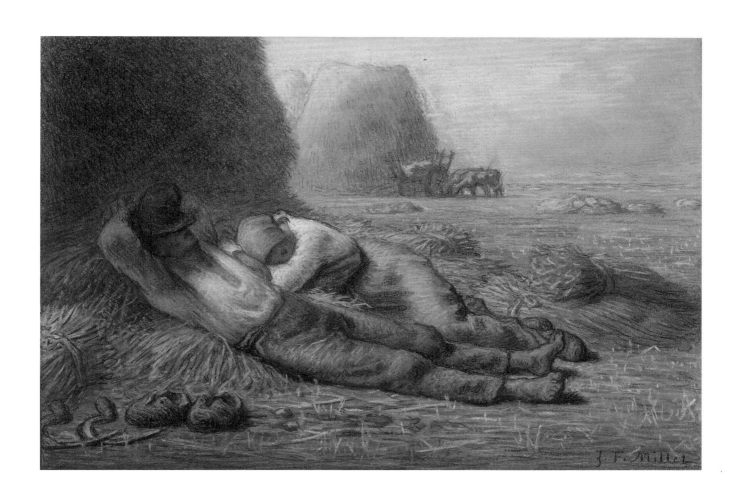

Jean-François Millet

Noonday Rest

1866
Pastel and black conté crayon on buff wove paper
Museum of Fine Arts, Boston
Cat. 41

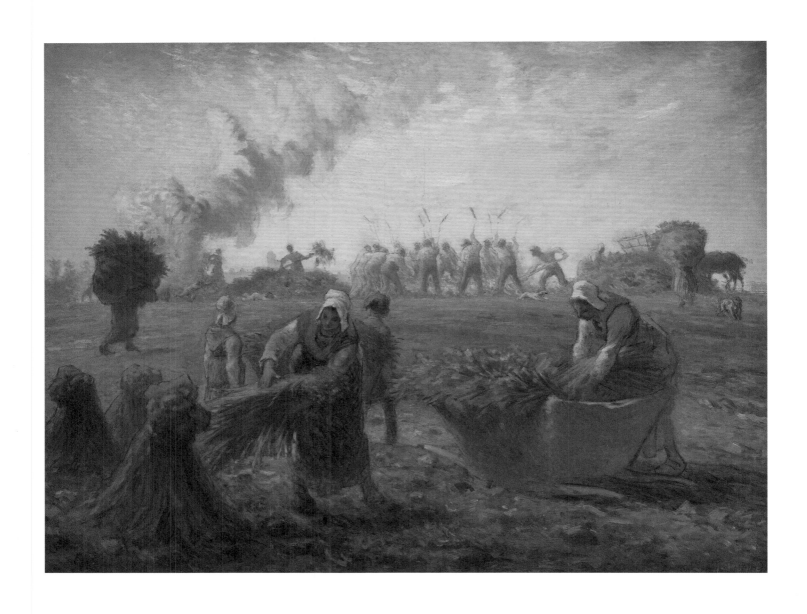

Jean-François Millet

Buckwheat Harvest, Summer

1868–74
Oil on canvas
Museum of Fine Arts, Boston
Cat. 42

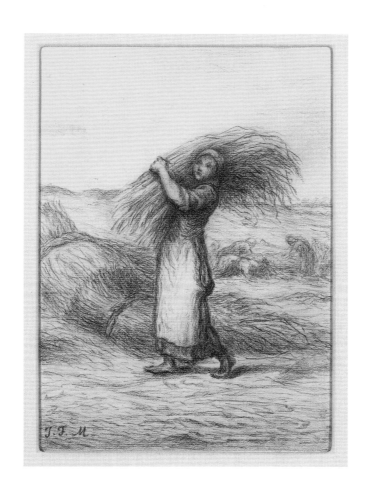

Jean-François Millet

Harvest Scene

n.d.
Charcoal on paper
Dallas Museum of Art, The Wendy and
Emery Reves Collection
Cat. 43

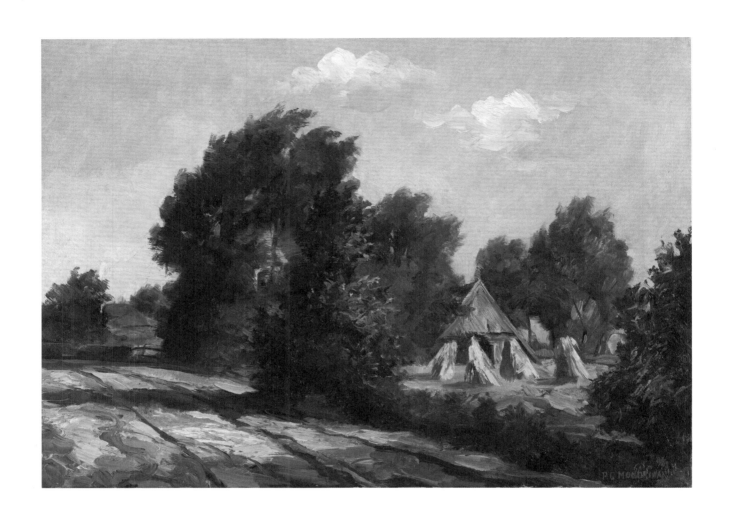

Piet Mondrian

Country Road and Farm

1893
Oil on canvas
Private collection, Netherlands

Cat. 44

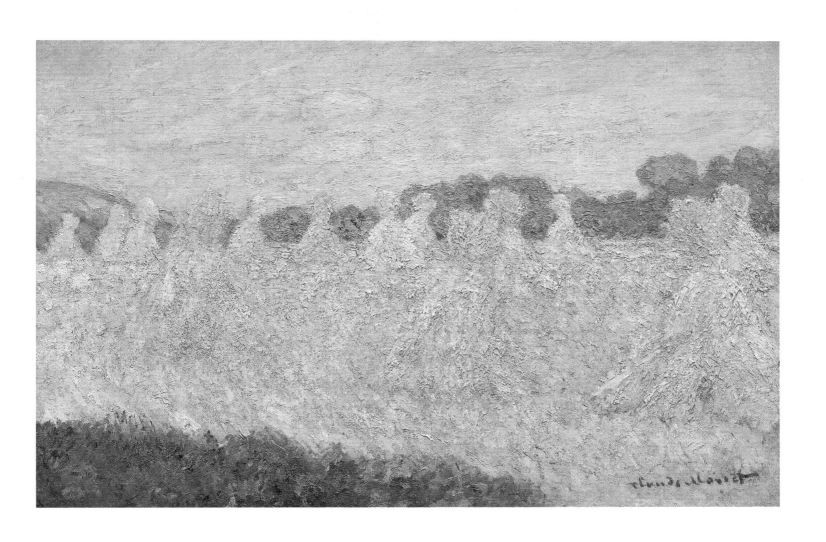

Claude Monet

The Young Ladies of Giverny, Sun Effect

1894
Oil on canvas
The Israel Museum, Jerusalem
Cat. 45

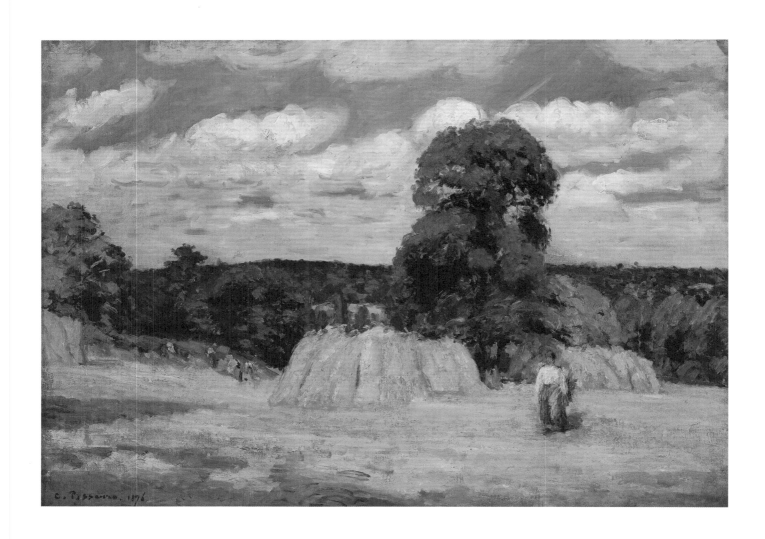

Camille Pissarro

The Harvest at Montfoucault

1876
Oil on canvas
Musée d'Orsay, Paris
Cat. 46

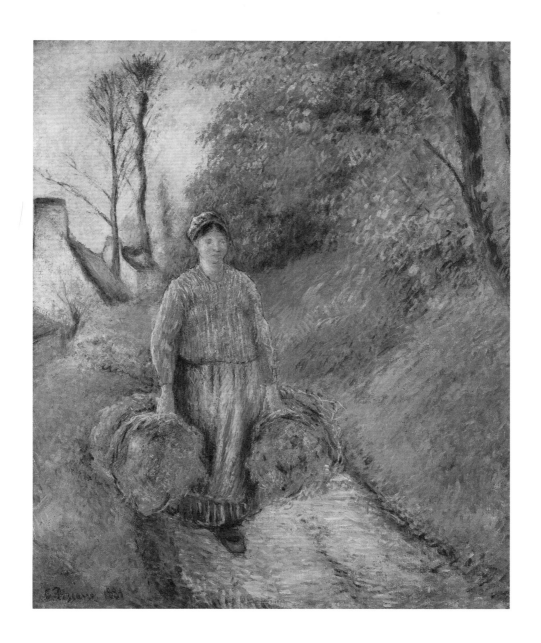

Camille Pissarro

Peasant Carrying Two Bales of Hay

1883
Oil on canvas
Dallas Museum of Art, Gift of the Meadows
Foundation, Incorporated
Cat. 47

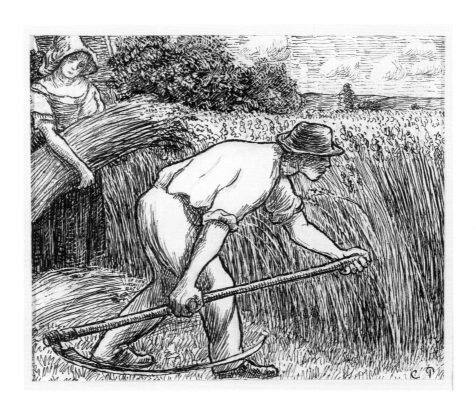

Camille Pissarro

The Harvest

c. 1895
Pen, ink, lead with gouache on paper
Dallas Museum of Art, The Wendy and
Emery Reves Collection
Cat. 48

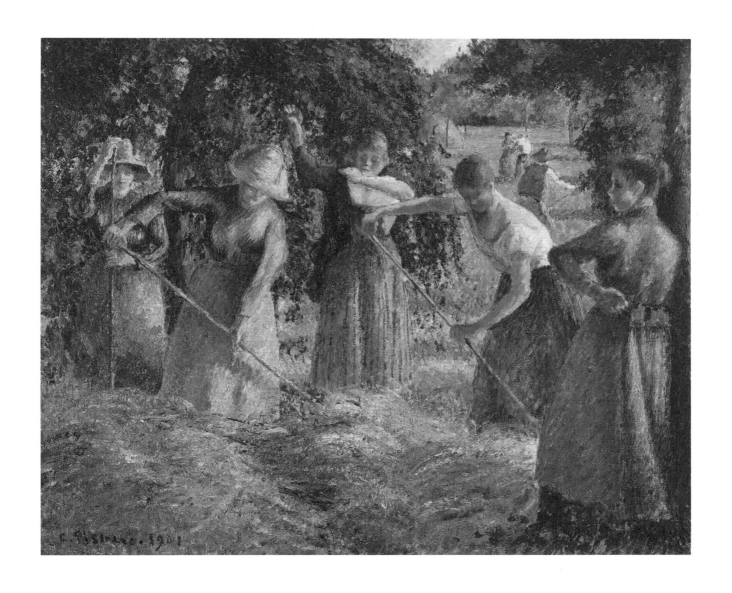

Camille Pissarro

Hay Harvest at Éragny

1901
Oil on canvas
National Gallery of Canada, Ottawa
Cat. 49

Gabriel Rigolot

Threshing Machine–Loiret

1893
Oil on canvas
Musée des Beaux-Arts, Rouen
Cat. 50

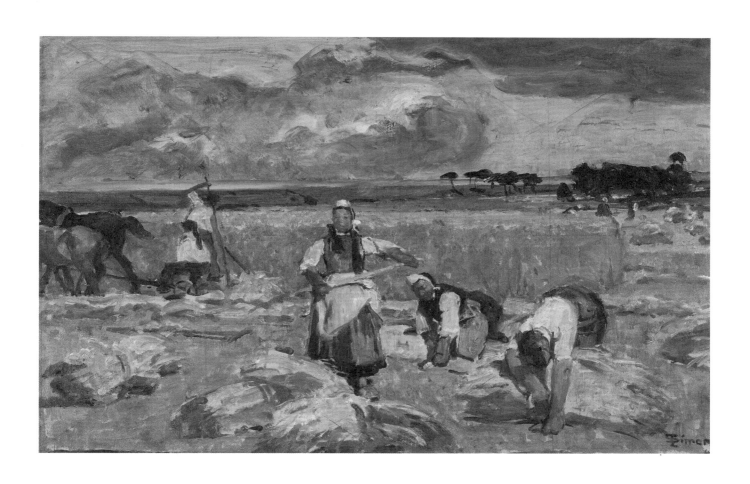

Lucien Simon

The Sheaves

1913
Oil on canvas
Musée des Beaux-Arts, Rennes
Cat. 51

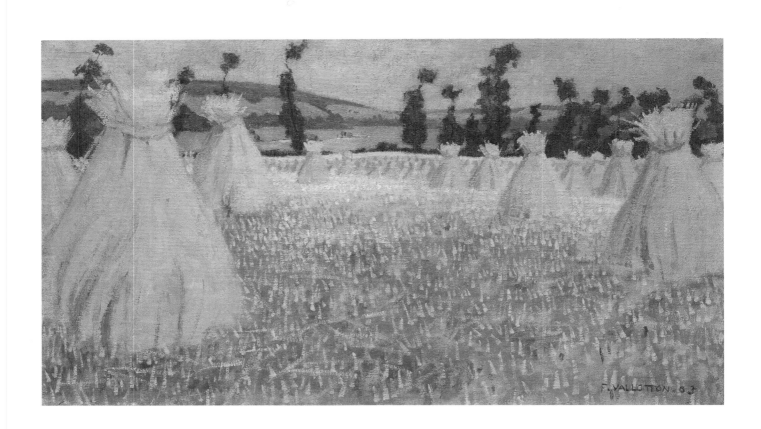

Félix Vallotton

Wheat, Arques-la-Bataille

1903
Oil on canvas
Private collection, Switzerland
Cat. 52

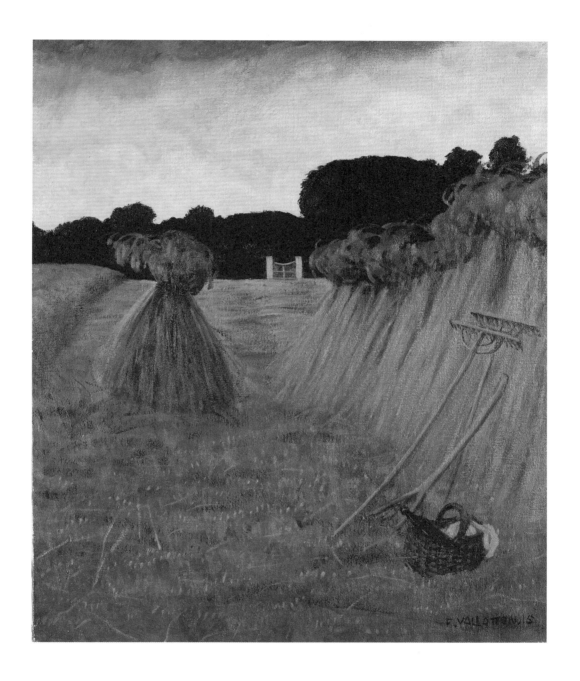

Félix Vallotton

The Sheaves

1914
Oil on canvas
Private collection, Switzerland
Cat. 53

Jules-Jacques Veyrassat

Harvest Scene

1866
Oil on canvas
The Walters Art Museum, Baltimore
Cat. 54

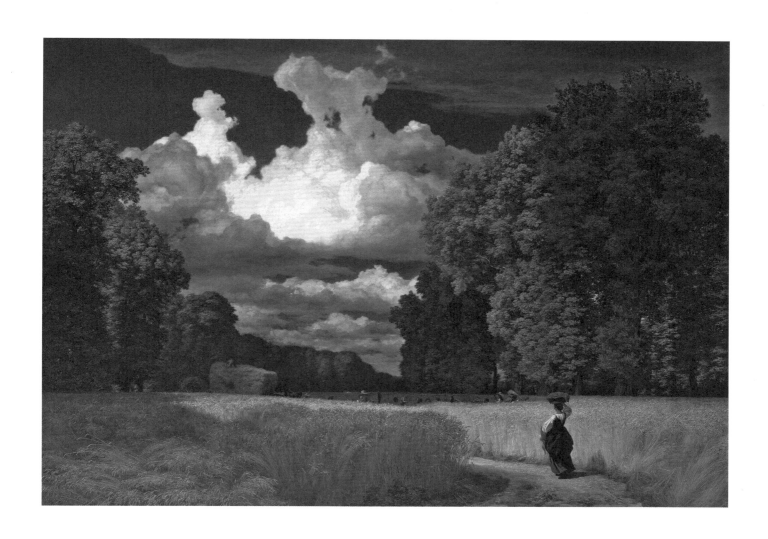

Robert Zünd

Harvest

1859–60
Oil on canvas
Kunstmuseum Basel
Cat. 55

Artist Biographies Laura Bruck

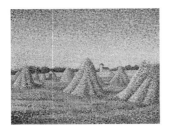

CHARLES ANGRAND
Criqueot-sur-Ocille 1854–1926 Rouen

Harvest
c. 1887
Cat. 1, p. 64

Born in a small village in Normandy, Charles Angrand received his training at the École Municipale des Beaux-Arts in Rouen. Moving to Paris in 1882, he aligned himself with avant-garde artists Georges Seurat, Paul Signac, Maximilien Luce, and Henri Cross, who were also beginning to explore optical effects, the division of tone, and color and light. Angrand made plein-air studies on the Island of Grande Jatte and in the Paris suburbs using the pointillist technique Seurat made famous, in which broad color areas are defined with short strokes of individual hues. The approach can be seen in Angrand's painting *Harvest*. Later, he adapted the technique to drawings in which he applied a black charcoal stick to a finely ridged paper. The ridges held the charcoal, but the paper showed through in the valleys between. This created the effect of a soft diffuse evening light that dissolves the forms and turns the landscape into an expansive abstraction of nature, as in *End of the Harvest* (cat. 2, p. 65). Along with Seurat, Signac, Luce, and Cross, Angrand participated in the first exhibitions of the Salon des Indépendants in 1884, and he continued his affiliation with these artists until 1901. In addition to artistic style, Angrand shared the group's political ideals: he, Camille Pissarro, and Félix Vallotton all contributed to Jean Grave's anarchist journal *Les Nouveaux Temps*. It was probably at the second presentation of the Salon des Indépendants that Van Gogh first saw the work of Angrand. Impressed by his use of color, Van Gogh wrote Angrand asking to meet and exchange works. The two met, but Angrand refused to exchange his *Feeding the Chickens* of 1884 for one of Van Gogh's paintings.

See Bogomila Welsh-Ovcharov, *The Early Works of Charles Angrand and His Contact with Vincent van Gogh* (Utrecht: Éditions Victorine, 1971).

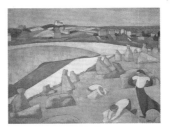

ÉMILE BERNARD
Lille 1868–1941 Paris

Harvest near the Seaside
1891
Cat. 3, p. 66

Émile Bernard was born in Lille but moved with his family to the Paris suburb of Asnières in 1881. In 1884, he enrolled in the atelier of the artist Ferdinand Cormon, an École des Beaux-Arts professor. At Cormon's studio, Bernard met Louis Anquetin, Henri de Toulouse-Lautrec, and Van Gogh, all young artists struggling to define their personal artistic identities. Van Gogh and Bernard became fast friends and corresponded regularly after Cormon expelled Bernard for insubordinate behavior. In his letters, Van Gogh offered the younger artist advice and criticism and shared his thoughts on the paintings he was working on at the moment. After Van Gogh's death, Bernard organized the first retrospective of his friend's work and began editing his many letters. After leaving Cormon's studio, Bernard traveled through Normandy and Brittany, where he met Paul Gauguin for the first time: the two artists reconnected in 1888 and began a fruitful collaboration that lasted until 1891. Bernard, like Gauguin and many other late-19th-century artists, was drawn to Brittany for its isolation and seemingly authentic vision of French rural culture. The painting *Harvest near the Seaside* depicts Saint-Briac, a town Bernard first visited in 1886 and summered in until his departure for Egypt in 1893. The artist observed with accuracy the agricultural developments in Brittany, which by this date included women laboring in the fields. He rejected a picturesque treatment of the scene and emphasized the rhythmic pattern of forms across the surface. Bernard's handling underscores the pictorial integration of harvesters and landscape, representing a symbiotic relationship between them.

See MaryAnne Stevens, *Émile Bernard 1868–1941: A Pioneer of Modern Art*, exh. cat. (Mannheim: Städtische Kunsthalle; Amsterdam: Van Gogh Museum; Zwolle: Waanders Publishers, 1990).

Nowhere in France are there finer peasantry; nowhere do we see more dignity of aspect in field labor.... We see the Breton peasants on their farms, reaping and carrying their small harvest of corn and rye, oats and buckwheat.... Here we are reminded at once of the French painters of pastoral life, of Jules Breton, Millet, and Rosa Bonheur.

H. Blackburn, *Artistic Travels in Normandy, Brittany, and the Pyrenees, Spain, and Algeria*, 1892

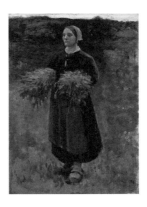

ERNST BIÉLER
Rolle, Switzerland 1863–1948 Lausanne

Plaiting Straw
1906–07
Cat. 4, p. 67

JULES-ADOLPHE-AIMÉ LOUIS BRETON
Courrières 1827–1906 Paris

The Gleaner
1859
Cat. 5, p. 68

Ernst Biéler was born in a small town on the shores of Lake Geneva and received art training at the École des Beaux-Arts in Paris while also studying informally with Jules Lefebvre and Gustave Boulanger. He actively exhibited in Paris for many years at such well-established institutions as the Salon des Artistes Français (1887), the Salon de la Société Nationale des Beaux-Arts (1887–1914), and the Exposition Universelle (1899, 1900). While maintaining ties to the cosmopolitan art world of Paris, Biéler explored the landscapes of the rural Swiss Alps in his paintings. In 1884, he discovered the Savièse region of Switzerland. The traditional way of life and the costumes of the peasants in this area high in the Alps fascinated Biéler, in much the same way that the rural culture of Brittany attracted artists in France. In 1900, he moved to Savièse and established an atelier that became a mecca for like-minded artists who identified themselves with the École Savièse—a group of Swiss painters interested in representing an idealized, preindustrial past. Around 1905, Biéler began searching for a new style appropriate to his depictions of the Swiss peasantry. He wrote: "I'm abandoning, little by little, the Parisian style. . . . I'm searching for a process in relation to the atmosphere, the absence of distance, and the absence of mist. . . . It is necessary to find a process that is more linear and graphic to express the marked character of the peasants, who have traits that seem to be engraved in wood." In meticulously rendered paintings such as *Plaiting Straw*, Biéler represented traditional rural life in Switzerland at the turn of the century. His paintings of the Alpine peasants responded to the Swiss agenda of establishing an image that could transcend the differences between the regional, political, and linguistic groups within the country. Biéler's alpine peasants were seen by contemporaries as a reference to the original Helvetic inhabitants of Switzerland.

See Jörg Zutter and Catherine Lepdor, *Ernst Biéler 1863–1948: Du réalisme à l'Art nouveau,* exh. cat. (Milan: Skira; Lausanne: Musée cantonal des Beaux-Arts, 1999).

Jules Breton came from a well-to-do family in the rural village of Courrières in far northwestern France, where his father supervised the land of the Duke of Duras and held other powerful positions. Breton received his first art lessons at the Collège Saint-Bertin. In 1843, the artist Félix de Vigne saw his sketches and asked the young artist to come to Ghent and study. Breton was in Belgium for several years while attending classes at the Academy of Fine Arts in Ghent and at the Antwerp Art Academy. In 1847, his family sent him to Paris to finish his training in the atelier of Michel-Martin Drolling. With the outbreak of the Revolution of 1848, Breton made paintings responding to the disastrous effects of political change on the urban poor. His love of nature, however, led him to devote his life's work to the representation of the rhythms of agricultural life that pervaded Courrières. Breton treated the subject of gleaning many times. The oil sketch *The Gleaner* is a preparatory work for the large-scale painting *The Return of the Gleaners* of 1859, which immediately won the artist much acclaim; it was bought by the emperor Napoleon III that same year and in 1862 sent to the Musées Impériaux. Van Gogh mentioned seeing it in 1875. Unlike Breton's previous treatments of the subject—in which he showed the peasants hard at work in the heat of the midday sun—in *The Return of the Gleaners,* he had them leaving the fields at dusk with the bundles of wheat they had gathered.

During the mid-19th century there was much debate about the long tradition of gleaning. Up until then, poor peasants had been allowed to pick up what was left after the harvest. By mid-century, landowners objected to gleaning as an infringement of their property rights, while others felt that outlawing the custom would further oppress the peasants. In his comments about gleaning, Breton remarked not on the political implications of the practice but rather on its religious and picturesque overtones. Later, he began to produce large paintings that focused on small groups or single figures, such as

CHARLES-FRANÇOIS DAUBIGNY
Paris 1817–1878 Paris

Summer Landscape
n.d.
Cat. 8, p. 71

The Gleaner of 1877 (cat. 7, p. 70), for which he made a carefully rendered preparatory drawing. The heroicized female peasants he depicted were likened in the contemporary press to caryatids from a Greek temple and modern Gaullish maidens. Breton was often compared to the other great painter of peasants, Jean-François Millet. Critics noted how Breton idealized his subjects, while Millet did not. Van Gogh often spoke of Millet and Breton in the same sentence, calling both of them "the voice of the wheat." Breton's long and successful career inspired another generation of realist painters, including Julien Dupré and Léon L'Hermitte.

See Annette B. Lacouture, *Jules Breton: Painter of Peasant Life,* exh. cat. (New Haven: Yale University Press in association with National Gallery of Ireland, 2002).

In my opinion, there was still progress up to Millet and Jules Breton, but to surpass them—don't even think of it. In the past, present, or future their genius may be equaled, but it will never be eclipsed.

Vincent van Gogh to Theo van Gogh, 1882

The engraver and painter Charles-François Daubigny came from an artistic family—his father, Edmond-François Daubigny, was his first teacher. Copying the landscapes of Jacob van Ruisdael and Nicolas Poussin at the Musée du Louvre was also a crucial component of his early training. In 1840 he received formal art training with Paul Delaroche, who also taught Jean-François Millet. During the late 1830s and throughout the 1840s, Daubigny produced mainly woodcuts and engravings, as both independent works and illustrations for books and magazines. Though he executed an engraving of a modern, mechanized *machine à battre le blé* (threshing machine) for the Société du Progrès pour l'Art Industriel, he never included signs of the industrialization of agriculture in his landscape paintings. After cementing his reputation as a graphic artist with a medal at the Salon of 1848 and receiving a government commission to produce an etching after Claude Lorrain, Daubigny began to focus his attention on painting. He traveled widely with his friend and fellow artist Jean-Baptiste Corot, painting the landscapes of France and Switzerland. In order to facilitate his plein-air painting, Daubigny converted a boat, *Le Botin,* into a permanent home and mobile studio, which he lived and worked on until his death in 1878. In 1857 Breton joined him on the rivers of France in search of suitable subjects. Unlike his predecessors, Daubigny took an interest in the transitoriness of nature and the atmosphere and attempted to capture it through his light and rapid brush strokes. While some critiqued his lack of finish, others, such as Claude Monet and Camille Pissarro, were inspired by both his style and his method of plein-air painting in their development of the radical innovations of impressionism. As a member of the Salon jury in the 1860s, Daubigny supported the work of such avant-garde artists as Paul Cézanne, Pissarro, and Auguste Renoir. Van Gogh admired Daubigny's work a great deal: he wrote to his brother Theo on several occasions commenting on his respect for the older painter's work. One of Van Gogh's final paintings before his death in 1890 was of Daubigny's garden in the village of Auvers.

See Madeleine Fidell-Beaufort and Janine Bailly-Herzberg, *Daubigny* (Paris: Éditions Geoffroy-Dechaume, 1975).

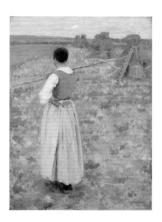

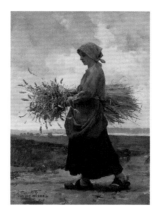

LOUIS PAUL DESSAR
Indianapolis, Indiana 1867–1952 Preston, Connecticut

Peasant Woman and Haystacks, Giverny
1892
Cat. 9, pp. 72–73

Born in the Midwest, Dessar moved to New York City as a young boy. From 1881 to 1883 he attended the City College of New York, and in 1883 he entered the National Academy of Design, where he studied under Lemuel Wilmarth and John Q. A. Ward. Like many American artists during the late 19th century, Dessar traveled to Paris for additional training. He studied at the Académie Julian with William Bouguereau and Robert Fleury and also took classes at the École des Beaux-Arts from 1889 to 1890. In his travels outside Paris, Dessar spent an eight-month period during 1891 and 1892 in Giverny, the rural village that began attracting artists after Claude Monet settled there in 1883. His only painting dating from this period, *Peasant Woman and Haystacks, Giverny,* is in the tradition of French peasant painting established by artists such as Jean-François Millet and Jules Breton.

Dessar's friend and fellow artist Theodore Robinson described his harvest paintings in Giverny: "His art is not very personal, but [it has] some qualities of tone and color. He is successful, sells anything once. He has no fear of the banal, of doing the already done, which is perhaps one secret of his prosperity. He has begun on the plain a square composition, setting sun, sheaves of grain . . . two girls in the foreground desperately 'familiar' as motif but not without charm and color and effect."

See William Gerdts, *Monet's Giverny: An Impressionist Colony* (New York: Abbeville Press, 1993).

JULIEN DUPRÉ
Paris 1851–1910 Paris

Returning from the Fields
n.d.
Cat. 11, p. 75

Julien Dupré received rigorous academic training in the studios of Isidore Pils, Georges Laugée, and Henri Lehmann. With his impeccable draftsmanship, he was considered by many to be one of the leaders of the second generation of realist painters. Like Jules Breton and Jean-François Millet before him, Dupré dedicated himself to images of peasants involved in various agricultural activities. In the manner of Breton, he invested his female subjects with a heroic aura. Dupré, however, usually shows peasants involved in some sort of vigorous labor, while Breton's figures are often still. After seeing a reproduction of one of Dupré's works, Van Gogh noted in a letter to his brother Theo dated November 1882 that his images of peasants seemed "so very energetic and faithfully done." Dupré's paintings and drawings were well received in France, winning medals at the Salon. It was in the United States, however, that he found his most dedicated following, among newly rich industrialists.

See Gabriel Weisberg, *The Realist Tradition: French Painting and Drawing, 1830–1900,* exh. cat. (Bloomington: Indiana University Press, 1980).

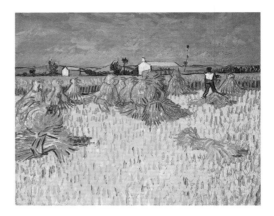

PAUL GAUGUIN
Paris 1848–1903 Marquesas Islands

Harvest: Le Pouldu
1890
Cat. 13, p. 77

Paul Gauguin was born in Paris during the unsettled political era of the Paris Commune in 1848. His family soon left for Lima, Peru, where Gauguin lived until he was seven. Between 1865 and 1871, he was a sailor with the merchant marines. After returning to France, he became a stockbroker under the guidance of family friend Gustave Arosa. Through Arosa's collection of art, Gauguin also became increasingly interested in both producing and collecting art. He owned Paul Cézanne's *The Harvest* of 1875–77, a painting that Van Gogh had admired at a gallery in Paris. By the 1880s Gauguin had decided to devote himself to art. His friendship with Pissarro and Cézanne provided him with connections to the impressionists. His early works, which he exhibited with that group, were met with critical indifference. With dwindling finances, Gauguin set out for Pont-Aven, Brittany, in 1886: he returned there in 1888 and again in 1889. The painting *Harvest: Le Pouldu* represents a field south of the village of Kerzellec, near Le Pouldu. Artists like Gauguin and Émile Bernard were drawn to the remoteness of the region and its ancient Breton culture. In reality, the distinctive costumes worn by the peasants were modern in origin and the area was experiencing rapid growth in commerce and industry. Between his trips to Brittany, Gauguin traveled to Martinique. It was in 1887 that Van Gogh first saw Gauguin's paintings from the Caribbean island, which persuaded him that here was someone capable of making an "art of the future." The two exchanged pictures and struck up a friendship. Van Gogh encouraged Gauguin to join him in Arles in 1888. Even after abruptly leaving the "Studio of the South" two months later, Gauguin continued to correspond with Van Gogh, describing his lithographs on zinc, which included the series *The Pleasures of Brittany* (cat. 12, p. 76).

See Douglas W. Druick and Peter Kort Zegers, *Van Gogh and Gauguin: The Studio of the South,* exh. cat. (New York: Thames and Hudson; Chicago: Art Institute of Chicago; Amsterdam: Van Gogh Museum, 2001).

VINCENT VAN GOGH
Zundert, Netherlands 1853–1890 Auvers-sur-Oise

Corn Harvest in Provence
17–23 June 1888
Cat. 24, p. 32

Born in the southern Netherlands, Vincent van Gogh was part of a family of clergymen and art dealers. His upbringing in a religious household (his father was a Protestant minister) was a crucial factor in his viewing and making of art throughout his life. By age sixteen, he dropped out of school to apprentice at his uncle's art gallery, Goupil & Cie. Van Gogh learned a great deal about old master and contemporary painting at the gallery and at museums, and began collecting prints by various artists. In Paris, he regularly visited the Musée du Louvre and the Musée du Luxembourg, where he was particularly impressed by the works of Jean-François Millet, Jules Breton, and Charles-François Daubigny. Eventually, his religious fervor conflicted with the commercial aspect of art dealing, and in 1876 he was fired.

After returning to the Netherlands in 1877, Van Gogh decided to become a preacher, and from 1878 to 1880 worked as an evangelist among the miners of the Borinage region of Belgium. A turning point in his career came in 1880 when he made a pilgrimage to the studio of Breton in Courrières. After this trip, he decided finally to dedicate his life to artmaking. Finding little inspiration and artistic guidance in rural Belgium, Van Gogh moved to Brussels, where he visited museums and studied drawing. He moved frequently between 1881 and 1883, continuing to hone his skills by studying and copying from his collection of prints. He returned to his parents' home in Nuenen in 1883. During this decade, he became increasingly interested in Émile Zola's literary representations of the stark and often brutal realities of peasant life, such as *La Terre* (*The Earth*) of 1887. He emulated Zola's literary model in his charcoal drawings of local farmworkers in the fields around Nuenen.

The next decisive event was Van Gogh's 1886 move to Paris, where he came into contact with the avant-garde movements of impressionism and postimpressionism. In response to art-

DANIEL RIDGWAY KNIGHT
Philadelphia, Pennsylvania 1839–1924 Rolleboise-par-Bonniers, France

Harvest Scene
1875
Cat. 33, p. 78

ists associated with these movements—Claude Monet, Camille Pissarro, Georges Seurat, and Charles Angrand—Van Gogh began to alter his technique and palette. He traded dark, heavy colors for contrasting hues of complementary colors and started using a more rhythmic and spontaneous brush stroke. While Van Gogh learned abundantly in Paris, like many of his contemporaries he yearned to leave the city for the countryside, and in 1888 departed for Arles in the south. Paul Gauguin soon joined him in what Van Gogh called the "Studio of the South." While their time together was short-lived and often tension-filled, it was also highly productive. Van Gogh worked daily in the fields, often comparing his work as an artist to that of the farmers he represented. At the end of the year, he began having attacks of mental illness and from 1889 to 1890 was institutionalized at an asylum in Saint-Rémy. He continued to paint—views from his window, which overlooked a wheat field (*Wheatfield with a Reaper* [cat. 28, p. 36]), and copies after prints by Millet. At this point, his work began to receive attention: in 1889 he sent six paintings to the exhibition of Les XX in Brussels and then participated in the 1890 Salon des Indépendants, where his paintings impressed Monet, Gauguin, and Pissarro. After leaving the asylum, Van Gogh spent the last period of his life in Auvers-sur-Oise, just north of Paris. It was here that he began a series of large-scale, double-square canvases that almost exclusively show rural scenes. On 27 July 1890, Van Gogh went out into the fields that he had represented so often in paint and shot himself in the chest: he died two days later.

On Van Gogh, see Selected Bibliography, p. 118.

After three years at the Philadelphia Academy of Fine Arts, Daniel Knight set out for Paris, where from 1861 to 1863 he pursued academic training at the atelier of the Swiss-born artist Charles Gabriel Gleyre and at the École des Beaux-Arts under Alexandre Cabanel. The outbreak of the American Civil War called Knight back to the United States, but in 1871 he and his family moved permanently to France. His painting trip to Barbizon in 1874 marked a turning point in his career, because it was there that he met Jean-François Millet, who offered him an artistic model for his peasant paintings. Critics saw a distinct difference between the two artists' works; writing in 1888, George Sheldon noted that "Mr. Knight does not see the sadness of French peasant life, but its gladness. He is neither a Millet nor a Zola."

See Pamela Beecher, *A Pastoral Legacy: Paintings and Drawings by the American Artists Ridgway Knight and Aston Knight,* exh. cat. (Ithaca: Herbert F. Johnson Museum of Art, 1989), and Gabriel Weisberg, *Beyond Impressionism: The Naturalist Impulse* (New York: Harry N. Abrams, 1992).

JACQUES-ADRIEN LAVIEILLE (AFTER J.-F. MILLET)
Paris 1818–1862 Paris

The Labors of the Fields
1853
Cat. 34, p. 79

Jacques-Adrien Lavieille was a well-known wood engraver of the mid-19th century, trained at the École des Beaux-Arts. He provided numerous engravings for leading journals such as *L'Artiste* and *Le Magasin pittoresque* and to publishers of many books, including the serial *Les Français peints par eux-mêmes* (Paris: L. Curmer, 1840–42) and novels by Honoré Balzac. Lavieille was a close friend of Jean-François Millet and engraved many of his works. It was Lavieille's print of Millet's *The Labors of the Fields* that Van Gogh copied in his series of the same title.

See Robert Herbert, *Peasants and "Primitivism": French Prints from Millet to Gauguin*, exh. cat. (South Hadley, Mass.: Mount Holyoke College Art Museum, 1995).

LÉON AUGUSTIN L'HERMITTE
Mont-Saint-Père, France 1844–1925 Paris

Wheatfield (Noonday Rest)
1886
Cat. 35, p. 80

L'Hermitte showed artistic promise at an early age, and after the Minister of State and Fine Art saw his sketches, he received an award to study art. In the early 1860s he enrolled at the École Impériale de Dessin (Petit École) at the atelier of Horace Lecoq de Boisbaudran in Paris. As a young artist, he produced mainly landscape paintings and charcoal drawings. Referring to L'Hermitte's charcoal drawings, Van Gogh commented that he was the "[Jean-François] Millet and Jules Breton of black and white." He also produced illustrations for books and magazines. As his work matured, L'Hermitte began painting rural genre scenes, including edifying views of laboring peasants that owe a great deal to Millet. He spent part of each year living and working in his native region, which allowed him to stay in close contact with his subjects and execute his precise sketches on location. In keeping with the tastes of the Salon public, he would rework his initial studies to include anecdotal details, as in *End of the Day* (cat. 36, p. 81), preparatory to *The Harvesters* of 1888–89 (cat. 37, pp. 82–83). L'Hermitte remained firmly attached to his birthplace in rural Mont-Saint-Père, returning every year to paint. *Wheatfield (Noonday Rest)* of 1886, a variant of a painting commissioned by two merchants named Arnold and Trip, represents a scene based on his observations of the harvest around his hometown.

See Gabriel Weisberg, *The Realist Tradition: French Painting and Drawing 1830–1900*, exh. cat. (Bloomington: Indiana University Press, 1980).

You never hear me being pessimistic about L'Hermitte, do you? I like L'Hermitte [and Jean-François Raffaelli] so much because their work is so thoroughly logical, sensible, and honest! I have here before me some figures; a woman with a spade, seen from behind; another bending to glean the ears of corn; another seen from the front, her head almost to the ground, digging carrots. I have been watching those peasant figures here for more than a year and a half, just to catch their character.

Vincent van Gogh to Theo van Gogh, 6 July 1885

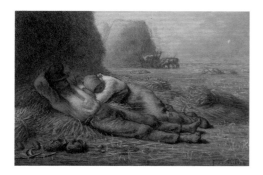

JEAN-FRANÇOIS MILLET
Gruchy, France 1814–1875 Barbizon

Noonday Rest
1866
Cat. 41, p. 87

Jean-François Millet was born into a prosperous peasant family in Normandy. As a boy, he took drawing lessons in the nearby town of Cherbourg from the portrait painter Bon de Mouchel as well as from the history painter Lucien-Théophile Langlois. The city of Cherbourg offered Millet a stipend to study with Paul Delaroche in Paris. During the 1840s he painted mainly portraits and genre and pastoral themes. His shift to scenes of rural labor coincided with his move to Barbizon to escape the chaos of the Revolution of 1848 in Paris. At the Salon of 1850, Millet attracted the attention of both liberal and conservative critics with *The Sower* of that year. Conservative critics were troubled by the image of the monumental peasant and his coarse, unidealized features. For liberal critics, however, it was the beginning of a new age in which the common man was deemed worthy of artistic representation. At the 1853 Salon, Millet won his first medal for the monumental painting *Harvesters Resting (Ruth and Boaz)* (cat. 38, p. 84), which incorporates both biblical references and links to well-known artistic precedents, including Pieter Breughel's *Harvest* of 1565 and Léopold Robert's *The Arrival of the Harvesters* of 1831.

Throughout his early career, Millet treated the theme of gleaning. His early treatments present a positive image of women gleaning that integrates them into the harvest. However, in later versions such as *The Gleaners* (cat. 39, p. 85), which he engraved about 1855 and painted in 1857, Millet separated the three women from the harvest, turning them into poor peasants authorized to gather only what has been left behind. Millet's peasant scenes were often compared to those by Jules Breton, whose heroicizing and idealizing of the peasant Millet himself disdained. In his one artistic reference to Breton, *Gleaner Returning Home with Her Grain* (cat. 40, p. 86), which dates from around 1857–62, Millet represented a single barefoot female peasant. The artist knew that no peasant would walk barefoot into a freshly harvested field and typically endeavored to dramatize the difficulties of peasant life. Alfred Sensier, Millet's biographer, encouraged his friend to soften his often coarse representation of peasants, and this image may have been the artist's demonstration that he could indeed compete on Breton's turf. Van Gogh was fascinated by Millet throughout his career, calling him "the voice of the wheat" and making copies after his work. In 1889, while at Saint-Rémy, the Dutch artist copied *Peasant Woman Binding Sheaves* (cat. 29, p. 37), from Millet's series *The Labors of the Field* of 1853. During the 1860s and 70s, Millet's reputation as the painter of peasants was established through the 1867 retrospective of his work at the Exposition Universelle in Paris. During his last years, Millet received commissions for paintings, including a four-part series on the seasons for Frédéric Hartmann that includes *Buckwheat Harvest, Summer* (cat. 42, p. 88). In this late work, Millet represented the multiple tasks of the harvest in a highly expressive and painterly style and, like his great admirer Van Gogh, identified color and brush stroke with moral qualities he ascribed to peasant life.

On Millet, see Selected Bibliography, p. 118.

Millet is the voice of the wheat.
Vincent van Gogh to Mr. Isaäcson, November 1889

PIET MONDRIAN
Amersfoort, Netherlands 1872–1944 New York

Country Road and Farm
1893
Cat. 44, p. 90

Piet Mondrian's first art teacher, J. B. Ueberfeldt, taught him using reproductions from 19th-century art journals. In 1892, Mondrian registered at the Rijksacademie van Beeldende Kunst in Amsterdam. During his early years in that city, the artist experimented with a variety of styles, including those of the Hague School, Amsterdam impressionism, and symbolism. His *Country Road and Farm* reflects the influence of impressionism in the Low Countries: he used a range of flowing brush strokes to create this picturesque landscape filled with trees and sheaves of wheat. The fluidity of Mondrian's handling relates paintings such as this to those of Van Gogh. While in Amsterdam, Mondrian may well have visited the 1892 Van Gogh exhibition organized by Van Gogh's sister-in-law, Joanna van Gogh. Like Mondrian, Van Gogh was dedicated to the material aspect of paint and to making his technique visible. Of course, Mondrian is best known for his geometric abstractions and collaboration with De Stijl in the 1920s. Much of this later mature work clearly relates to his earlier exploration of the elemental horizontals and verticals of this landscape.

See Hans Janssen and Joop M. Joosten, *Mondrian 1892–1914: The Path to Abstraction,* exh. cat. (Zwolle: Waanders Publishers; Fort Worth: Kimball Art Museum, 2002).

CLAUDE MONET
Paris 1840–1926 Giverny

The Young Ladies of Giverny, Sun Effect
1894
Cat. 45, p. 91

Monet was born in Paris but grew up in the northern coastal town of Le Havre. It was there that he met his first teacher, Eugène Boudin, who encouraged the eighteen-year-old to begin painting outdoors. Later, in Paris, Monet studied at the atelier of Charles Gabriel Gleyre, where he met Auguste Renoir, Alfred Sisley, and Jean Frédéric Bazille. After limited success at the Salon, Monet became the leader of the impressionists, who showed their works independently, at private galleries. Monet chose not to live in Paris but in the Seine valley and in 1883 settled in Giverny. The subtle, varying effects of seasonal and atmospheric changes there fascinated the artist, and he endeavored to capture these variations by painting the same subject multiple times. His *The Young Ladies of Giverny, Sun Effect* is one of a series of three paintings of small haystacks, or *meulettes,* he saw in the countryside near his home. Each *meulette* was made up of many small sheaves and served as provisional shelter against inclement weather until a proper grain stack could be constructed, like the ones seen in Monet's famous *Grainstack* series of 1890–91. Van Gogh's brother Theo, who ran the Montmartre branch of the art gallery Bossod, Valadon & Cie, introduced Vincent to Monet's work. The French artist's impressionist paintings inspired Van Gogh to lighten his palette and use a more spontaneous brush stroke. In his letters, Van Gogh often used works by Monet as a yardstick against which to measure his own. He must have felt immense pride when Monet described his paintings as the best on view at the 1890 Salon des Indépendants.

See George T. M. Shackelford and Fronia E. Wissman, *Monet and Renoir and the Impressionist Landscape,* exh. cat. (Ottawa: National Gallery of Canada, 2000), and Richard Brettell, Sylvie Gache-Patin, Françoise Heilbrun, and Scott Schaeffer, *A Day in the Country: Impressionism and the French Landscape,* exh. cat. (Los Angeles: Los Angeles County Museum of Art, 1984).

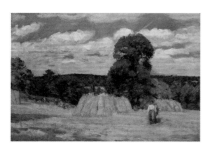

CAMILLE PISSARRO
Danish West Indies 1830–1903 Paris

The Harvest at Montfoucault
1876
Cat. 46, p. 92

GABRIEL RIGOLOT
Paris 1862–1932 Paris

Threshing Machine–Loiret
1893
Cat. 50, p. 96

After spending his youth in the Danish West Indies, Camille Pissarro settled in France in 1855. On his arrival in Paris, he registered at the École des Beaux-Arts and the Académie Suisse. Like Claude Monet, Pissarro's early attempts at exhibiting at the Salon met with a tepid response, and he sought out alternative venues. Along with artists such as Monet and Auguste Renoir, Pissarro showed his work at all eight impressionist exhibitions held between 1874 and 1886; *The Harvest at Montfoucault* of 1876 was included that year. In the 1880s Pissarro shifted his focus to large-scale figure paintings. To his chagrin, critics often compared the peasant pictures he began making to those of Jean-François Millet. In 1882 he protested: "They throw Millet at me, but Millet was biblical! For a Jew that seems to me a bit much." As his humanitarian anarchism crystalized during the 1880s, figure subjects gave him greater scope than landscapes did to construct images of rural life. This shift may have had something to do with increasing his marketability, because peasant pictures were popular with consumers. Both traditional and avant-garde artists admired the work of Pissarro—Jules Breton and Léon L'Hermitte alike praised the peasant compositions. In 1886 Van Gogh's brother Theo, who showed Pissarro's paintings at his gallery in Paris, introduced the two artists. Pissarro's combination of peasant subject matter and neo-impressionist style spoke to Van Gogh, who observed in a letter to Theo in June 1888 that "what Pissarro says is true, you must boldly exaggerate the effects of either harmony or discord which colors produce. It is the same as in drawing—the drawing, accurate color, is perhaps not the essential thing to aim at, because the reflection of reality in a mirror, if it could be caught, color and all, would not be a painting at all, nothing more than a photograph."

See Joachim Pissarro, *Camille Pissarro* (London: Harry N. Abrams, 1993), and Richard Thomson, *Camille Pissarro: Impressionism, Landscape, and Rural Labor*, exh. cat. (London: The Herbert Press, 1990).

Gabriel Rigolot studied in Paris under Léon-Germain Pelouse and Auguste Allongé and exhibited frequently at the Salon from 1886. In addition to recognition at the Salon, he was made a knight of the Legion of Honor in 1901 and named a member of the Society of French Orientalists for his dramatic paintings of North Africa. Rigolot also painted plein-air landscapes in Brittany. Prior to the introduction of machines like the one featured in his painting *Threshing Machine–Loiret,* wheat was separated by hand. In the traditional process, represented in the background of Jean-François Millet's *Buckwheat Harvest, Summer* of 1868–74 (cat. 42, p. 88), the cut grain was placed on the ground and hit with a flail. After the wheat was threshed, it was tossed into the air to remove the chaff from the grain in a process called winnowing. The threshing machine, or *machine à battre le blé,* mechanized what had been a time-consuming process by rapidly removing the chaff from the grain. Representations of modern farm equipment were relatively rare in late-19th-century paintings; Charles-François Daubigny once illustrated a threshing machine in an etching for a scientific magazine, but never painted one, and Camille Pissarro included farm machinery in only four of his many peasant paintings. Even as late as 1890, art critics were surprised when they saw contemporary farm equipment represented at the Salon.

See Richard Brettell and Caroline Brettell, *Painters and Peasants in the Nineteenth Century* (Geneva: Skira, 1983).

They will take your field and your crops away from you. You yourself will be taken and fastened to some iron machine, smoking and clanking, and all wrapped in coal smoke. You will have to rock your arms over a piston ten or twelve thousand times a day. This is what they will call agriculture.

Elisée Reclus to his "brother the peasant," 1894

LUCIEN SIMON
Paris 1861–1945 Paris

The Sheaves
1913
Cat. 51, p. 97

Lucien Simon studied for a short time with William Bouguereau and Tony Robert-Fleury at the Académie Julian in Paris. Like Paul Gauguin and Émile Bernard, he began spending summers in Brittany during the 1890s. While he painted genre scenes and portraits, he is probably best remembered for his scenes of Breton peasant life. In *The Sheaves,* Simon represents a harvest scene in which three women bundle cut grain into sheaves, while in the background two men ride on a reaping machine. Modernized farm equipment was a rare sight in late-19th- and 20th-century painting. It is no wonder, then, that Simon relegated the technology to the background and focused on the traditional scene of women bundling wheat. He exhibited widely and won prizes that included an honorable mention and third-place medal at the Salon; in 1893 he was elected a member of the Société Nationale des Beaux-Arts. Simon also showed his work with the Société Nouvelle, which was presided over by Auguste Rodin.

See Patrick Descamps, ed., *Des plaines à l'usine: Images du travail dans la peinture française de 1870 à 1914,* exh. cat. (Paris: Somogy Éditions d'Art, 2001), and Isabelle Chanoir, *La Muse bretonne,* exh. cat. (Rennes: Musée des Beaux-Arts, 2000).

FÉLIX VALLOTTON
Lausanne 1865–1925 Paris

Wheat, Arques-la-Bataille
1903
Cat. 52, p. 98

Like Ernst Biéler, Félix Vallotton was born in Switzerland and moved to Paris, in his case to begin studies at the Académie Julian in 1882. He became a close friend of his teacher and mentor Charles Maurin and of Charles Cottet (also a good friend of the artist Lucien Simon). Vallotton worked as a printmaker for many years, making etchings after well-known works by artists such as Rembrandt van Rijn and Jean-François Millet for popular journals. In 1892 he joined the Nabis and began producing woodcuts, a practice he continued until 1902, when he returned to painting. The landscapes he produced in the 20th century are quite different from those dating to earlier in his career. Unlike Vallotton's plein-air paintings of the 1880s and 90s, his *Wheat, Arques-la-Bataille* is intended not to reproduce nature as it presents itself at a certain time or place but rather to represent it as an idealized abstraction. The artist produced a series of preparatory drawings that he used in the studio as memory aids for the painting. Contemporaries of Vallotton saw in his work a perpetuation of the synthesism and cloisonism of Paul Gauguin and Émile Bernard, evident in his use of ornamental elements, the flat distribution of color, and abbreviated forms.

See Sasha Newman, Marina Ducrey, and Lesley Baier, *Félix Vallotton,* exh. cat. (New Haven: Yale University Press; New York: Abbeville Press, 1991).

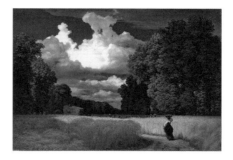

JULES-JACQUES VEYRASSAT
Paris 1828–1893 Paris

Harvest Scene
1866
Cat. 54, p. 100

Jules-Jacques Veyrassat's father was a jeweler and wanted his son to pursue the family business. Veyrassat enrolled in the state school of industrial drawing in Paris, but with the Revolution of 1848 the jewelry market was ruined, and he was able to devote himself to his artistic interests. He is believed to have studied with H. Lehmann and F. Beson. To support himself early on, he made copies of paintings at the Musée du Louvre and etchings after works by well-known artists including Charles-François Daubigny and Rembrandt van Rijn. Veyrassat won distinction for his etchings at the Salon in 1866 and 1869. There is very little record of his life, but the titles of his many landscape paintings reveal that he traversed France, visiting Brittany, Normandy, Fontainebleau, and the Pyrenees. Veyrassat treated the harvest theme throughout his career; *Harvest Scene* depicts the cutting and gathering of grain on the left and the creation of large grain stacks on the right. During the 1880s, the artist traveled to North Africa and painted scenes in Algiers.

See William R. Johnston, *The Nineteenth-Century Paintings in the Walters Art Gallery* (Baltimore: Walters Art Gallery, 1982).

ROBERT ZÜND
Lucerne 1827–1909 Lucerne

Harvest
1859–60
Cat. 55, p. 101

Robert Zünd began his artistic training in Geneva under François Diday and Alexandre Calame. In 1852 he traveled to Paris and studied with Nicolas Cabat, Alexandre Descamps, François-Louis Français, and Constant Troyon; he also learned from the Barbizon school artists. In 1860 he spent several months in Dresden before returning to Switzerland, where he settled in Lucerne. He took part in many exhibitions in his native country between 1852 and 1871 and won a gold medal at the Exposition de Bern in 1857. His landscapes balance the classical compositions of Claude Lorrain and the realist paintings of the Barbizon school. Zünd created several preparatory drawings for *Harvest*. In contrast to the first of his quickly executed oil sketches, the final painting shows an idealized vision of nature with a woman dwarfed by the plentiful, grain-filled plain that surrounds her.

See Franz Zelger, ed., *Robert Zünd in seiner Zeit,* exh. cat. (Lucerne: Kunstmuseum Luzerne, 1978).

Checklist of the Exhibition

1. Charles Angrand
Harvest
c. 1887
Oil on canvas
14⅞ × 18⅛ in.
Association des Amis du Petit Palais,
Musée d'art moderne, Geneva
Page 64

2. Charles Angrand
End of the Harvest
1890s
Conté crayon
19 × 24¾ in.
© The Cleveland Museum of Art
Purchase from the J. H. Wade Fund
1999.49
Page 65

3. Émile Bernard
Harvest near the Seaside
1891
Oil on canvas
27⅝ × 36¼ in.
Musée d'Orsay, Paris
Page 66

4. Ernst Biéler
Plaiting Straw
1906–07
Watercolor on paper glued to canvas
47 × 31¼ in.
Musée Cantonal des Beaux-Arts
de Lausanne
Long-term loan of the Gottfried Keller
Foundation
Page 67

5. Jules-Adolphe-Aimé Louis Breton
The Gleaner
1859
Oil on board
20¹⁵⁄₁₆ × 14⅝ in.
The Museum of Fine Arts, Houston
Gift of Dr. and Mrs. H. B. Eisenstadt
Page 68

6. Jules-Adolphe-Aimé Louis Breton
Le Colza (The Rapeseed Harvest)
1860
Oil on canvas
37 × 54 in.
The Corcoran Gallery of Art,
Washington, D.C.
William A. Clark Collection
26.14
Page 69

7. Jules-Adolphe-Aimé Louis Breton
The Gleaner
1877
Black chalk and pencil on paper
11½ × 7¾ in.
The Snite Museum of Art, University of
Notre Dame, Indiana
On loan from Mr. and Mrs. Noah L. Butkin
as a promised gift
L1979.017.001
Page 70

8. Charles-François Daubigny
Summer Landscape
n.d.
Oil on panel
10 × 18⅞ in.
Ateneum Art Museum, Finnish National
Gallery, Helsinki
Page 71

9. Louis Paul Dessar
Peasant Woman and Haystacks, Giverny
1892
Oil on canvas
18¼ × 13 in.
Terra Foundation for American Art, Chicago
Daniel J. Terra Collection
1993.9
Pages 72–73

10. Julien Dupré
The Gleaners
1880
Oil on canvas
36½ × 51 in.
Private collection, California. Photograph
courtesy of Rehs Galleries, Inc., New York
Page 74

11. Julien Dupré
Returning from the Fields
n.d.
Oil on canvas
18 × 13 in.
Private collection, Texas. Photograph
courtesy of Rehs Galleries, Inc., New York
Page 75

12. Paul Gauguin
The Pleasures of Brittany
1889
Lithograph on zinc, printed on yellow
wove paper
7⅞ × 9½ in.
Sterling and Francine Clark Art Institute,
Williamstown, Massachusetts, 1962.58
Page 76

13. Paul Gauguin
Harvest: Le Pouldu
1890
Oil on canvas
28¾ × 36⅜ in.
Tate. Accepted by H.M. Government in lieu
of tax and allocated to the Tate Gallery 1966
Page 77

14. Vincent van Gogh
Peasant Woman Binding a Sheaf of Grain
(JH 871/F 1263)*
August 1885
Chalk on paper
21⅞ × 16⅞ in.
Collection Kröller-Müller Museum, Otterlo,
Netherlands
Page 22

15. Vincent van Gogh
Peasant Woman Binding Sheaves
(JH 868/F 1266)
August 1885
Black chalk on paper
22⅜ × 17½ in.
Van Gogh Museum, Amsterdam
Vincent van Gogh Foundation
Page 23

16. Vincent van Gogh
Peasant Woman Binding Wheat Sheaves
(JH 869/F 1264)
August 1885
Chalk, washed, on paper
17¾ × 20¾ in.
Collection Kröller-Müller Museum, Otterlo,
Netherlands
Page 24

17. Vincent van Gogh
Peasant Woman, Carrying a Sheaf of Grain
(JH 870/F 1267)
August 1885
Black chalk on paper
22⅜ × 16½ in.
The National Museum of Art, Architecture,
and Design–National Gallery, Oslo
Page 25

18. Vincent van Gogh
Sheaves of Wheat (JH 914/F 193)
Second half of August 1885
Oil on canvas
15⅝ × 11¾ in.
Collection Kröller-Müller Museum, Otterlo,
Netherlands
Page 26

19. Vincent van Gogh
*Wheat Field with a Reaper and a Peasant
Woman Gleaning* (JH 917/F 1301)
Second half of August 1885
Chalk and paint on paper
10⅝ × 15¼ in.
Collection Kröller-Müller Museum, Otterlo,
Netherlands
Page 27

20. Vincent van Gogh
*Wheat Field with Reaper and a Woman
Binding Sheaves* (JH 915/F 1321r)
Second half of August 1885
Black chalk on paper
10⅝ × 15½ in.
Van Gogh Museum, Amsterdam
Vincent van Gogh Foundation
Page 28

21. Vincent van Gogh
Stooks and a Mill (JH 913/F 1340)
Second half of August 1885
Black chalk, heightened with white,
on paper
8⅞ × 11⅝ in.
Van Gogh Museum, Amsterdam
Vincent van Gogh Foundation
Page 29

22. Vincent van Gogh
Stooks and a Peasant Stacking Sheaves
(JH 912/F 1339)
Second half of August 1885
Black chalk on paper
7¾ × 12⅞ in.
Van Gogh Museum, Amsterdam
Vincent van Gogh Foundation
Page 30

23. Vincent van Gogh
Wheat Field with Sheaves and Windmill
(JH 911/F 1319v)
Second half of August 1885
Black chalk on paper
17½ × 22¼ in.
Van Gogh Museum, Amsterdam
Vincent van Gogh Foundation
Page 31

24. Vincent van Gogh
Corn Harvest in Provence (JH 1481/F 558)
17–23 June 1888
Oil on canvas
19¾ × 23⅝ in.
The Israel Museum, Jerusalem
Gift of Yad Hanadiv, Jerusalem, from
the collection of Miriam Alexandrine de
Rothschild, daughter of the late Baron
Edmond de Rothschild
B66.06.1039
Page 32

25. Vincent van Gogh
Wheat Field (JH 1480/F 561)
17–23 June 1888
Oil on canvas
20¾ × 25¼ in.
Honolulu Academy of Arts
Gift of Mrs. Richard A. Cooke and Family
in memory of Richard A. Cooke
1946 (377.1)
Page 33

26. Vincent van Gogh
The Harvest (JH 1516/F 1491)
c. July 1888
Pen and brown ink over graphite
12⅝ × 9⅜ in.
Collection of Mr. and Mrs. Paul Mellon
National Gallery of Art, Washington, D.C.
Page 34

* This and all following catalogue raisonné numbers can be referenced in Jan Hulsker, *The New Complete Van Gogh: Paintings, Drawings,
Sketches: Revised and Enlarged Edition of the Catalogue Raisonné of the Works of Vincent van Gogh* (Amsterdam and Philadelphia: John
Benjamins, 1996), and J. B. de la Faille, *The Works of Vincent van Gogh* (New York: Reynal in association with Morrow, 1970).

27. Vincent van Gogh
Arles: View from the Wheatfields
(JH 1544/F 1492)
6–8 August 1888
Reed, quill pens, and brown ink
12⅜ × 9½ in.
The J. Paul Getty Museum, Los Angeles
2001.25
Page 35

28. Vincent van Gogh
Wheat Field with a Reaper (JH 1773/F 618)
5–6 September 1889
Oil on canvas
29 × 36¼ in.
Van Gogh Museum, Amsterdam
Vincent van Gogh Foundation
Page 36

29. Vincent van Gogh (after J.-F. Millet)
Peasant Woman Binding Sheaves
(JH 1781/F 700)
First half of September 1889
Oil on canvas
17 × 13¼ in.
Van Gogh Museum, Amsterdam
Vincent van Gogh Foundation
Page 37

30. Vincent van Gogh
Ears of Wheat (JH 2034/F 767)
June 1890
Oil on canvas
25⅜ × 19 in.
Van Gogh Museum, Amsterdam
Vincent van Gogh Foundation
Page 38

31. Vincent van Gogh
Sheaves of Wheat (JH 2125/F 771)
July 1890
Oil on canvas
19⅞ × 39¾ in.
Dallas Museum of Art
The Wendy and Emery Reves Collection
Pages 40–41

32. Vincent van Gogh
Women Crossing the Fields (JH 2112/F 819)
July 1890
Oil on paper
12⅝ × 25¼ in.
Collection of the McNay Art Museum,
San Antonio
Bequest of Marion Koogler McNay
Page 39

33. Daniel Ridgway Knight
Harvest Scene
1875
Oil on canvas
40 × 59½ in.
Chrysler Museum of Art, Norfolk, Virginia
Gift of Walter P. Chrysler, Jr.
71.2118
Page 78

34. Jacques-Adrien Lavieille
(after J.-F. Millet)
The Labors of the Fields
1853
From a series of ten wood engravings
17⅜ × 26⅜ in.
Van Gogh Museum, Amsterdam
Vincent van Gogh Foundation
Page 79

35. Léon Augustin L'Hermitte
Wheatfield (Noonday Rest)
1886
Oil on canvas
21 × 30½ in.
Museum of Fine Arts, Boston
Bequest of Julia C. Prendergast in memory
of her brother James Maurice Prendergast
44.38
Page 80

36. Léon Augustin L'Hermitte
End of the Day
Probably 1887
Pastel on laid paper
9¼ × 12 in.
Musée des Beaux-Arts, Reims
Page 81

37. Léon Augustin L'Hermitte
The Harvesters
1888–89
Oil on canvas
21 × 30½ in.
The Art Institute of Chicago
Mr. and Mrs. Martin A. Ryerson Collection
1933.1139
Pages 82–83

38. Jean-François Millet
Harvesters Resting (Ruth and Boaz)
1850–53
Oil on canvas
26½ × 47⅛ in.
Museum of Fine Arts, Boston
Bequest of Mrs. Martin Brimmer
06.2421
Page 84

39. Jean-François Millet
The Gleaners
c. 1855
Etching
7½ × 10 in.
Dallas Museum of Art
Bequest of Vera C. Perren in memory
of Mr. and Mrs. Oliver Jackson Perren
Page 85

40. Jean-François Millet
Gleaner Returning Home with Her Grain
c. 1857–62
Black conté crayon on paper
14½ × 11½ in.
The Frick Art and Historical Center,
Pittsburgh
Page 86

41. Jean-François Millet
Noonday Rest
1866
Pastel and black conté crayon on buff
wove paper
11½ × 16½ in.
Museum of Fine Arts, Boston
Gift of Quincy Adams Shaw through
Quincy Adams Shaw, Jr., and Mrs. Marian
Shaw Haughton
17.1511
Page 87

42. Jean-François Millet
Buckwheat Harvest, Summer
1868–74
Oil on canvas
33⅝ × 43¾ in.
Museum of Fine Arts, Boston
Gift of Quincy Adams Shaw through
Quincy Adams Shaw, Jr., and Mrs. Marian
Shaw Haughton
17.1533
Page 88

43. Jean-François Millet
Harvest Scene
n.d.
Charcoal on paper
9¼ × 7¼ in. (framed)
Dallas Museum of Art
The Wendy and Emery Reves Collection
Page 89

44. Piet Mondrian
Country Road and Farm
1893
Oil on canvas
17⅛ × 23¾ in.
Private collection, Netherlands
Page 90

45. Claude Monet
The Young Ladies of Giverny, Sun Effect
1894
Oil on canvas
25⅝ × 39¼ in.
The Israel Museum, Jerusalem
Bequest of Loula D. Lasker, New York, to
American Friends of The Israel Museum
B61.12.1059
Page 91

46. Camille Pissarro
The Harvest at Montfoucault
1876
Oil on canvas
25¼ × 36 in.
Musée d'Orsay, Paris
Page 92

47. Camille Pissarro
Peasant Carrying Two Bales of Hay
1883
Oil on canvas
28⅞ × 23⅝ in.
Dallas Museum of Art
Gift of the Meadows Foundation,
Incorporated
Page 93

48. Camille Pissarro
The Harvest
c. 1895
Pen, ink, lead with gouache on paper
7½ × 8⅛ in.
Dallas Museum of Art
The Wendy and Emery Reves Collection
Page 94

49. Camille Pissarro
Hay Harvest at Éragny
1901
Oil on canvas
21¼ × 25½ in.
National Gallery of Canada, Ottawa
Page 95

50. Gabriel Rigolot
Threshing Machine–Loiret
1893
Oil on canvas
64⅛ × 90⅝ in.
Musée des Beaux-Arts, Rouen
Page 96

51. Lucien Simon
The Sheaves
1913
Oil on canvas
17¾ × 27¼ in.
Musée des Beaux-Arts, Rennes
Page 97

52. Félix Vallotton
Wheat, Arques-la-Bataille
1903
Oil on canvas
15 × 26¼ in.
Private collection, Switzerland
Page 98

53. Félix Vallotton
The Sheaves
1914
Oil on canvas
28½ × 23¾ in.
Private collection, Switzerland
Page 99

54. Jules-Jacques Veyrassat
Harvest Scene
1866
Oil on canvas
30¼ × 59 in.
The Walters Art Museum, Baltimore
Page 100

55. Robert Zünd
Harvest
1859–60
Oil on canvas
44 × 61⅝ in.
Kunstmuseum Basel
Accession no. 660
Page 101

Selected Bibliography

Vincent van Gogh

Allen, Christopher, and Wilfred Niels Arnold. *Van Gogh: His Sources, Genius, and Influence.* Exh. cat. Sydney: Art Exhibitions Australia Limited, 1993.

The Complete Letters of Vincent van Gogh. 2nd ed. 3 vols. Greenwich, Conn.: New York Graphic Society, 1959.

Druick, Douglas W., and Peter Kort Zegers. *Van Gogh and Gauguin: The Studio of the South.* Exh. cat. New York: Thames and Hudson; Chicago: Art Institute of Chicago; Amsterdam: Van Gogh Museum, 2001.

Herzogenrath, Wulf, and Dorothee Hansen, eds. *Van Gogh: Fields.* Exh. cat. Ostfildern-Ruit: Hatje Cantz, 2002.

Heugten, Sjraar van. *Vincent van Gogh Drawings.* 3 vols. Amsterdam: Van Gogh Museum, 1996.

Heugten, Sjraar van, Leo Jansen, and Chris Stolwijk, eds. *Van Gogh's Imaginary Museum: Exploring the Artist's Inner World.* Exh. cat. Amsterdam and New York: Van Gogh Museum in association with Harry N. Abrams, 2003.

Homburg, Cornelia. *The Copy Turns Original: Vincent van Gogh and a New Approach to Traditional Art Practice.* Amsterdam and Philadelphia: John Benjamins, 1996.

———. *Vincent van Gogh and the Painters of the Petit Boulevard.* Exh. cat. St. Louis: Saint Louis Art Museum in association with Rizzoli International Publications, 2001.

Hulsker, Jan. *The New Complete Van Gogh: Paintings, Drawings, Sketches: Revised and Enlarged Edition of the Catalogue Raisonné of the Works of Vincent van Gogh.* Amsterdam and Philadelphia: John Benjamins, 1996.

Ives, Colta, Susan Alyson Stein, Sjraar van Heugten, and Maria Vellekoop. *Vincent van Gogh: The Drawings.* Exh. cat. New York: Metropolitan Museum of Art; Amsterdam: Van Gogh Museum; New Haven and London: Yale University Press, 2005.

Kōdera, Tsukasa. *Vincent van Gogh: Christianity versus Nature.* Amsterdam and Philadelphia: John Benjamins, 1990.

Lord, Douglas, ed. and trans. *Vincent van Gogh Letters to Émile Bernard.* New York: Museum of Modern Art, 1938.

Maurer, Naomi Margolis. *The Pursuit of Spiritual Wisdom: The Thought and Art of Vincent van Gogh and Paul Gauguin.* Madison: Fairleigh Dickinson University Press, 1998.

Meissner, W. W. *Vincent's Religion: The Search for Meaning.* New York: Peter Lang, 1997.

Mothe, Alain. *Vincent van Gogh à Auvers-sur-Oise.* Paris: Éditions du Valhermeil, 1987.

Pickvance, Ronald. *Van Gogh in Arles.* Exh. cat. New York: Metropolitan Museum of Art in association with Harry N. Abrams, 1984.

———. *Van Gogh in Saint-Rémy and Auvers.* Exh. cat. New York: Metropolitan Museum of Art, 1986.

Pollock, Griselda. "The Ambivalence of the Maternal Body, Re/drawing Van Gogh." *Differencing the Canon: Feminist Desire and the Writing of Art's Histories.* London and New York: Routledge, 1999.

Silverman, Debora. "At the Threshold of Symbolism: Van Gogh's *Sower* and Gauguin's *Vision after the Sermon.*" *Lost Paradise: Symbolist Europe.* Exh. cat. Montreal: Montreal Museum of Fine Arts, 1995.

———. *Van Gogh and Gauguin: The Search for Sacred Art.* New York: Farrar, Straus and Giroux, 2000.

Stolwijk, Chris, and Richard Thomson. *Theo van Gogh: Art Dealer, Collector, and Brother of Vincent van Gogh.* Exh. cat. Amsterdam: Van Gogh Museum in association with Zwolle: Waanders, 1999.

Sund, Judy. *Van Gogh.* London: Phaidon, 2002.

———. "The Sower and the Sheaf: Biblical Metaphor in the Art of Vincent van Gogh." *The Art Bulletin* 70 (December 1988): 660–76.

———. *True to Temperament: Van Gogh and French Naturalist Literature.* Cambridge, England: Cambridge University Press, 1992.

Tilborgh, Louis van, Sjaar van Heugten, and Philip Conisbee. *Van Gogh & Millet.* Exh. cat. Zwolle: Waanders b.v.; Amsterdam: Rijksmuseum Vincent van Gogh, 1989.

Tilborgh, Louis van, Sjraar van Heugten, and Marie-Pierre Salé. *Millet/Van Gogh.* Exh. cat. Paris: Éditions de la Réunion des Musées Nationaux, 1998.

Tilborgh, Louis van, Sjraar van Heugten, and Philip Conisbee. *Millet, Van Gogh.* With introduction by Marie-Pierre Salé. Paris: Réunion des Musées Nationaux, 1998.

Uitert, Evert van, ed. *Van Gogh in Brabant: Paintings and Drawings from Etten and Nuenen.* Exh. cat. Zwolle: Waanders, 1987.

Welsh-Ovcharov, Bogomila. *Vincent van Gogh and the Birth of Cloisonism.* Exh. cat. Toronto: Art Gallery of Ontario, 1981.

Wolk, Johannes van der, Ronald Pickvance, and E. B. F. Pey, *Vincent van Gogh: Drawings.* Exh. cat. New York: Rizzoli, 1990.

Zemel, Carol. "Sorrowing Women, Rescuing Men: Van Gogh's Images of Women and Family." *Art History* 10 (September 1987): 351–68.

———. *Van Gogh's Progress: Utopia, Modernity, and Late-Nineteenth-Century Art.* Berkeley: University of California Press, 1997.

Jean-François Millet

Coughlin, Maura. "The Artistic Origins of the French Peasant Painter: Jean-François Millet: Between Normandy and Barbizon." Ph.D. diss., New York University, Institute of Fine Arts, 2001.

———. "Millet's Milkmaids." *Nineteenth-Century Art Worldwide*. Vol. 2 (Winter 2003), http://www.19thc-artworldwide.org/winter_03/articles/coug.html (accessed 29 December 2005).

Fratello, Bradley. "France Embraces Millet: The Intertwined Fates of *The Gleaners* and *The Angelus*." *The Art Bulletin* 85 (December 2003): 685–701.

Gautier, Théophile. "Salon de 1857." *L'Artiste* 2 (20 September 1857): 35.

Herbert, Robert. *Jean-François Millet*. Exh. cat. London: Arts Council of Great Britain, 1976.

———. *Millet's 'Gleaners.'* Exh. cat. Minneapolis: Minneapolis Institute of Arts, 1978.

Moreau-Nélaton, Étienne. *Millet raconté par lui-même*. 3 vols. Paris: H. Laurens, 1921.

Murphy, Alexandra. *Jean-François Millet*. Exh. cat. Boston: Museum of Fine Arts, 1984.

Murphy, Alexandra, Richard Rand, Brian T. Allen, James Ganz, and Alexis Goodin. *Jean-François Millet: Drawn into the Light*. Exh. cat. Williamstown, Mass.: Sterling and Francine Clark Art Institute, 1999.

Sensier, Alfred. *Jean-François Millet: Peasant and Painter*. Translated by Helena De Kay. Boston: James R. Osgood, 1881.

———. *La Vie et l'oeuvre de J.-F. Millet*. Paris: A. Quantin, 1881.

19th-Century Landscape Painting and the Representation of Peasants and Agriculture

Athanassoglou-Kallmyer, Nina. "Cézanne and Delacroix's Posthumous Reputation." *The Art Bulletin* 87 (March 2005): 111–29.

Bodelson, Merete. "Gauguin's Cézannes." *The Burlington Magazine* 104 (May 1962): 204–11.

Bouyer, Raymond. *Le Paysage dans l'art*. Paris: L'Artiste—Revue de Paris, 1894.

Brettell, Richard. *Impressionist Paintings, Drawings, and Sculpture from the Wendy and Emery Reves Collection*. Exh. cat. Dallas: Dallas Museum of Art, 1985.

Brettell, Richard, and Caroline Brettell. *Painters and Peasants in the Nineteenth Century*. Geneva: Skira, 1983.

Brettell, Richard, Sylvie Gaché-Patin, Françoise Heilbrun, and Scott Schaeffer. *A Day in the Country: Impressionism and the French Landscape*. Exh. cat. Los Angeles: Los Angeles County Museum of Art, 1984.

Clark, T. J. *The Absolute Bourgeois: Artists and Politics in France, 1848–51*. London: Thames and Hudson, 1973.

Dabrowski, Magdalena. *French Landscape: The Modern Vision 1880–1920*. Exh. cat. New York: Museum of Modern Art and Harry N. Abrams, 1999.

Descamps, Patrick, ed. *Des Plaines à l'usine: Images du travail dans la peinture française de 1870 à 1914*. Exh. cat. Paris: Somogy Éditions d'Art, 2001.

Fowle, Frances, and Richard Thomson, eds. *Soil and Stone: Impressionism, Urbanism, Environment*. Aldershot: Ashgate, 2003.

Green, Nicholas. *The Spectacle of Nature: Landscape and Bourgeois Culture in Nineteenth-Century France*. Manchester: Manchester University Press, 1990.

Greenspan, Taube G. "'Les Nostalgiques' Re-Examined: The Idyllic Landscape in France 1890–1905." Ph.D. diss., City University of New York, 1981.

Herbert, Robert. "City vs. Country: The Rural Image in French Painting from Millet to Gauguin." *Artforum* 8 (February 1970): 44–55.

———. *Peasants and "Primitivism": French Prints from Millet to Gauguin*. Exh. cat. South Hadley, Mass.: Mount Holyoke College Art Museum, 1995.

House, John. *Landscapes of France: Impressionism and Its Rivals*. Exh. cat. London: The Hayward Gallery, 1995.

———. *Impressionism: Paint and Politics*. New Haven and London: Yale University Press, 2004.

Lees, Sarah, ed. *Bonjour, Monsieur Courbet!: The Bruyas Collection from the Musée Fabre, Montpellier*. Exh. cat. Paris: Éditions de la Réunion des Musées Nationaux; Williamstown, Mass.: Sterling and Francine Clark Art Institute, 2004.

Nochlin, Linda. *Realism*. New York: Penguin, 1971.

Payne, Christina. *Toil and Plenty: Images of the Agricultural Landscape in England, 1780–1890*. Exh. cat. New Haven and London: Yale University Press, 1993.

Price, Roger. *A Social History of Nineteenth-Century France*. New York: Holmes and Meier, 1987.

Rewald, John. *Post-Impressionism from Van Gogh to Gauguin*. New York: Museum of Modern Art, 1962.

Sturges, Hollister, ed. *The Rural Vision: France and America in the Late Nineteenth Century*. Exh. cat. Omaha: Joslyn Art Museum, 1987.

Thomas, Greg M. *Art and Ecology in Nineteenth-Century France: The Landscape of Théodore Rousseau*. Princeton: Princeton University Press, 2000.

Thomson, Richard. *Landscape Painting in France, 1874–1914*. Exh. cat. Edinburgh: National Gallery of Scotland, 1994.

———. ed. *Framing France*. Manchester: Manchester University Press, 1998.

Weber, Eugen. *Peasants into Frenchmen: The Modernization of Rural France 1870–1914*. Stanford: Stanford University Press, 1976.

Weisberg, Gabriel. *The Realist Tradition: French Painting and Drawing, 1830–1900*. Exh. cat. Bloomington: Indiana University Press, 1980.

———. *Beyond Impressionism: The Naturalist Impulse*. New York: Harry N. Abrams, 1992.

For brief bibliographic information on individual artists, see the entries in the Artist Biographies.

Additional Photography and Copyright Credits